IMAGES
of America

PHILADELPHIA'S GOLDEN AGE OF RETAIL

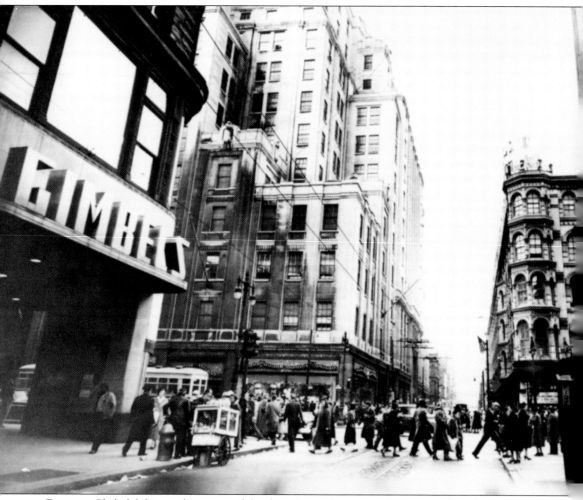

For many Philadelphians, the center of the shopping universe was the intersection of Market and Eighth Streets, where the following three of Philadelphia's "Big Five" department stores confronted each other: Gimbel Brothers (at left), Strawbridge & Clothier (center), and Lit Brothers (right). The remaining two of the big five, Wanamaker's and Snellenburg's, were located a few blocks west on Market Street. This c. 1950 photograph, looking north on Eighth Street across Market Street, shows holiday shoppers hurrying between the three stores. (Temple University Libraries/ Urban Archives.)

ON THE COVER: From June 23 to June 27, 1936, Philadelphia hosted the Democratic National Convention, where Franklin D. Roosevelt was nominated for a second term as president. East Market Street, the city's primary retail corridor, was a sea of stars and stripes as Strawbridge & Clothier (center), Lit Brothers (right), and other department stores welcomed the Democrats to town. Although America was in the depths of the Depression, Market Street (here, looking northwest from Eighth Street) appeared prosperous and bustling. Located across Market Street from Lit Brothers, the Capitol Theatre offered the combined delights of Joan Bennett, Fred McMurray, and free air-conditioning. (Free Library of Philadelphia.)

IMAGES
of America

PHILADELPHIA'S GOLDEN AGE OF RETAIL

Lawrence M. Arrigale and Thomas H. Keels

ARCADIA
PUBLISHING

Published by Arcadia Publishing
Charleston, South Carolina

Printed in the United States of America

Library of Congress Control Number: 2011934988

For all general information, please contact Arcadia Publishing:
Telephone 843-853-2070
Fax 843-853-0044
E-mail sales@arcadiapublishing.com
For customer service and orders:
Toll-Free 1-888-313-2665

Visit us on the Internet at www.arcadiapublishing.com

For Shirley Sue Swaab and Nick Finamore, in loving memory

CONTENTS

ACKNOWLEDGMENTS

Philadelphia's Golden Age of Retail would not have been possible without the help and generosity of the many individuals and institutions that make the Philadelphia region such a bountiful mother lode for historians.

We wish to thank the following people for opening their organizations' archives to us, and for their assistance in helping us track down unusual and arresting images for this book: Alexander Bartlett, librarian, and the volunteers of the Germantown Historical Society; Alyssa R. Bendetson of Macy's, Inc.; Michael Bolton and Lucy Clemens of the Opera Company of Philadelphia; Aurora Deshauteurs and her associates at the Print and Picture Collection of the Free Library of Philadelphia; Jill Pasternak of WRTI-FM; David Rowland and Mary Washington of the Old York Road Historical Society; and Brenda Galloway-Wright, associate archivist, and John Pettit, assistant archivist, of Temple University Libraries' Urban Archives.

We are especially indebted to the individuals who shared their private photographs and memorabilia as well as their memories with us: Michael V. Ciliberti; the late Bruce Conner; Laura Dinkins-White; Elsie Fisher; Janet and Hugh Gilmore; James H. Hill; Jeffrey Holder; Harry Kyriakodis; Susan Anne Maser; Diane Mattis; Tim McFarlane; Linde Meyer; Paul M. Puccio; Robert Morris Skaler; Mr. and Mrs. Francis R. Strawbridge III; Anne Swoyer; and William A. Zulker.

Darcy Mahan and Erin Vosgien, our current and former editors at Arcadia Publishing, offered encouragement and guidance at every step of the process, and helped to bring the project to fruition smoothly.

Finally, the writers would like to thank their parents (biological in one case and honorary in the other), Rita and Lawrence E. Arrigale, for sharing their constant love and support as well as their own recollections of Philadelphia's golden age of retail.

Many of the images in this volume appear courtesy of the Print and Picture Collection of the Free Library of Philadelphia (PPC/FLOP); Temple University Libraries, Urban Archives (TUL/UA); the Old York Road Historical Society (OYRHS); and the Germantown Historical Society (GHS). If no courtesy line is indicated, the image comes from the authors' personal collection.

INTRODUCTION

Say the words *Wanamaker's, Strawbridge & Clothier,* or *Gimbels* to any Philadelphian of a certain age, and they will respond like Marcel Proust after munching a plateful of madeleines. Out will pour vivid memories from decades past—finding the perfect designer dress for a pittance in Lits' bargain basement, enjoying an elegant lunch in Strawbridge & Clothier's Corinthian Room, flying above Wanamaker's toy department in a miniature monorail, and nervously watching Santa ascend a fire-truck ladder to the top floor of Gimbels on a frosty Thanksgiving morning.

Our city's numerous department stores and specialty shops, with their Aladdin's caves of gorgeously displayed goods, have left indelible impressions on generations of Philadelphians. Our goal with *Philadelphia's Golden Age of Retail* is not just to take a nostalgic shopping trip to all those stores that are not there anymore but to honor their contributions to the city's social and cultural history.

From the Civil War until the Vietnam War—the golden age of American upward mobility—the big five department stores (Wanamaker's, Strawbridge & Clothier, Gimbels, Lits, and Snellenburg's) and their shorter-lived cohorts welcomed hundreds of thousands of Philadelphians into the middle class. Whether you were a typewriter or secretary outfitting her first flat in 1880s Frankford or a corporate couple negotiating the nuances of social life in 1960s Bryn Mawr, the Big Five would show you the appropriate mode of dress, decoration, dining, and diversion. And once you were ready to take the next step up the social ladder, the boutiques of Chestnut Street were on hand with the proper Paris gowns, bespoke men's suits, engraved stationery, and sterling silver baby rattles. Long before *lifestyle* entered the English language, Philadelphia merchants were selling the concept to their customers.

The owners of these stores took their responsibilities seriously. The founding families of the Big Five retained control of their enterprises well into the 20th century, and two of the families (the Strawbridges and Clothiers) ran their shop until it was sold in 1996. These department-store dynasties wanted to do more than sell their customers another pair of jeans. They wanted to enhance Philadelphians' lives by exposing them to the finest art, the latest technology, the most exotic imports, and the most exciting celebrities. In the process, they not only enriched themselves but also afforded thousands of employees a comfortable life through a liberal system of discounts, health insurance, stock-option plans, sales incentives, and a wide array of cultural and athletic activities.

It was not always like this. Until the late 1860s, shopping in Philadelphia was simple in theory, although often complicated in practice. Shoppers went to individual stores or craftsmen for each of their needs. For clothing or fabric, it was the dry goods store; for hats, the milliner; for silver, the silversmith; and so on. There was no such thing as one-stop or even one-price shopping then. The price quoted would vary from customer to customer; haggling, today limited to flea markets and Middle Eastern bazaars, was common in every venue. "Cash on the barrelhead" was the ironclad rule, except for the most favored, trustworthy clients.

7

In 1876, Philadelphia celebrated the centennial of American independence with the most elaborate world's fair the country had ever seen. That year, John Wanamaker changed the face of retailing in Philadelphia and America forever with his "New Kind of Store," the Grand Depot. At two acres, the Depot was larger than any outlet seen in the city before, with a "half-million dollar stock, divided into six departments for the outfitting of men and boys." Located at Thirteenth and Market Streets, across from the large hole that would someday be Philadelphia City Hall, it was far removed from the major retail hub at Eighth and Market Streets. And Wanamaker began to aggressively advertise and promote his business in ways that no one had tried before.

Before the Grand Depot was a year old, the number of its departments had tripled to eighteen with the addition of white goods, linens, ladies' suits, shoes, and more. Soon, the other dry goods and men's stores along Market Street began to departmentalize and adapt Wanamaker's practices in their own unique ways. By the early 20th century, Market Street East was lined with department stores—not just Wanamaker's and Strawbridge & Clothier, but Gimbel Brothers, Lit Brothers, N. Snellenburg & Co., Frank & Seder, Blauner's, and H.L. Green.

Philadelphia, then the third largest city in the country, had the people and the wealth to keep all these stores buzzing. As the "workshop of the world" and a major financial center, Philadelphia produced a sizable middle class that was more likely to own their homes than residents of other American cities. Between 1890 and 1930, the city's population nearly doubled from one to almost two million people. Every day, another million suburbanites poured into Center City through a vast network of subway, trolley, and train lines, most of which emptied onto Market Street. It has been said that by 1930, the intersection of Market and Eighth Streets—where Strawbridge & Clothier, Gimbel Brothers, and Lit Brothers rubbed shoulders—generated more sales revenues than anywhere else in America.

With so much competition close at hand, "innovate or die" was the motto for Philadelphia department stores. Every weapon in the arsenal of modern American merchandising was perfected along Market Street during the 20th century, from elaborate window and in-store displays, fashion shows, bargain basements, special sales, art exhibitions, contests, movie and television tie-ins, international festivals, point-of-sale marketing, radio advertising (in the early 1920s, all major local radio stations were owned by department stores), and in-house television. Even that most beloved example of store branding, the Thanksgiving Day Parade (although usurped by Macy's New York in 1924), was originated by Gimbels in Philadelphia in 1920!

It was too good to last. As more and more Philadelphians decamped to the suburbs, the department stores opened suburban branches and mall stores to retain their business. But sales and revenues dropped at their aging Center City stores as Market Street began a drawn-out deterioration after the 1950s. At the same time, the stores struggled to fend off competition from a new breed of discount outlet like K-Mart and Walmart. During the 1970s and 1980s, the Gallery at Market East, the new commuter rail tunnel connecting Suburban Station with Reading Terminal and the Pennsylvania Convention Center, helped to revive Market Street as a commercial center.

But all the development could not halt the social and economic factors that led to the demise of the department store in Philadelphia as well as in other cities. Starting with Frank & Seder in 1953, the major Market Street stores closed one by one: Snellenburg's in 1963, Lit Brothers in 1977, Gimbel Brothers in 1986, Wanamaker's in 1995 (although Macy's currently holds court in its historic building), and, finally, Strawbridge & Clothier (truncated to Strawbridge's) in 2006. During the same period, most of the iconic specialty shops of Chestnut and Walnut Streets also shut their doors. By the dawn of the 21st century, the sun had set on Philadelphia's golden age of retail.

One

THE EARLY YEARS

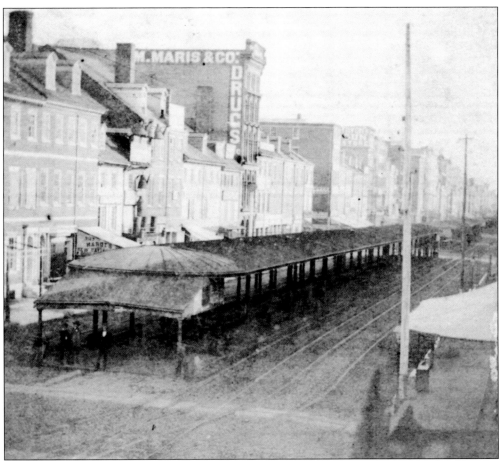

By the mid-19th century, the market sheds that had run down the center of Market Street since the city's founding had become an obstacle to development. On the reverse of this 1859 stereoscopic view of the stalls at Eighth and Market Streets is printed a "Farewell Address of the Market Houses to the People of Philadelphia." It reads, "In our early years, you were wont to pet us . . . styling us 'SPLENDID MARKET HOUSES,' . . . But of late . . . the cry 'away with them' has been loud and clamorous." Shortly afterwards, the stalls were torn down, clearing Market Street to become the city's premier commercial avenue. (James Hill Jr.)

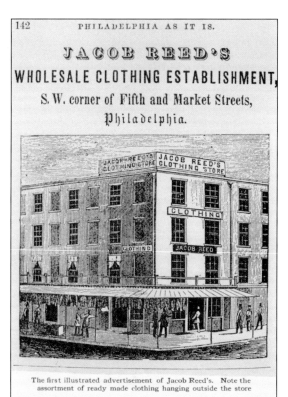

JACOB REED'S
WHOLESALE CLOTHING ESTABLISHMENT,
S. W. corner of Fifth and Market Streets,
Philadelphia.

The first illustrated advertisement of Jacob Reed's. Note the assortment of ready made clothing hanging outside the store

In 1824, Jacob Reed opened his first men's clothing store at 246 Market Street. Jacob Reed's store would ultimately become Philadelphia's premier outfitter for men and boys. His first illustrated advertisement in 1852 shows the store at the southwest corner of Fifth and Market Streets, already its sixth location. Young, fast-growing stores like Jacob Reed's seemed to be constantly on the move as they sought larger quarters.

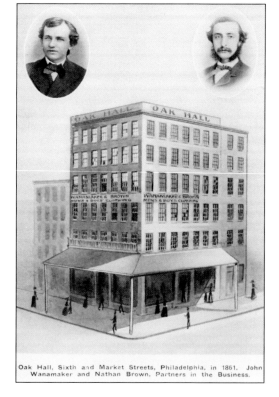

Oak Hall, Sixth and Market Streets, Philadelphia, in 1861. John Wanamaker and Nathan Brown, Partners in the Business.

In April 1861, on the eve of the Civil War, John Wanamaker and his brother-in-law Nathan Brown opened Oak Hall as a "Men's and Boys' Clothing Store" on the first floor of McNeille's Folly, so called because it was an unusually tall six stories. The building at the southeast corner of Sixth and Market Streets had formerly been the site of the President's House (now part of Independence National Historical Park).

In 1790, Secretary of State Thomas Jefferson had his office in this typical Philadelphia townhouse at the northwest corner of Eighth and Market Streets. By 1864, the area had become "the chosen place of active business," and the site was occupied by J.C. Strawbridge & Co. Wholesale and Retail Dry Goods. Four years later, Strawbridge would partner in business with Isaac H. Clothier, another young Quaker merchant.

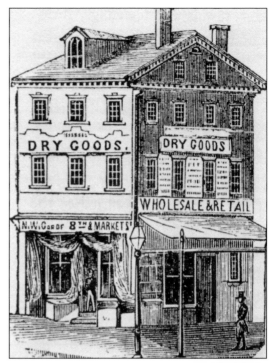

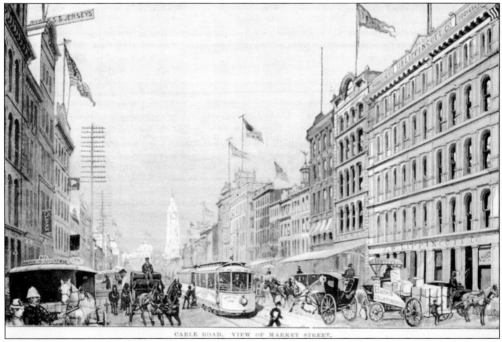

By 1890, the horse-drawn trolleys, which had replaced the trains on Market Street, were themselves replaced by cable cars, as seen in this contemporary engraving. This view, looking west toward Philadelphia City Hall, shows the J.B. Lippincott Publishing Co. at 715–717 Market Street at right. Several years later, the Lippincott Building would be absorbed by an expanding Lit Brothers Department Store, founded at the northeast corner of Eighth and Market Streets in 1893.

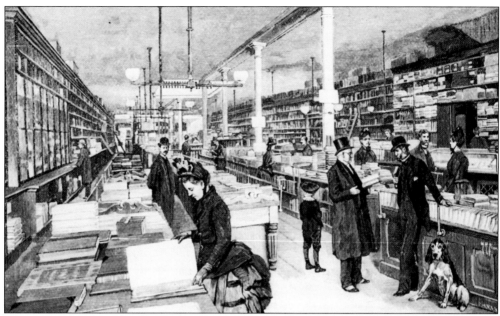

Bibliophiles browse inside the Lippincott bookstore on the first floor of the Lippincott Building at 715–717 Market Street. Lippincott's was founded by Joshua Ballinger Lippincott in 1836 and became one of Philadelphia's premier publishing houses, releasing Harper Lee's *To Kill A Mockingbird* and Thomas Pynchon's *V*. After numerous mergers, it exists today as Lippincott Williams & Wilkins, a medical and academic publisher headquartered in Philadelphia.

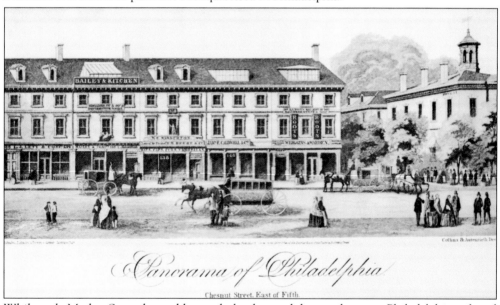

While early Market Street housed large wholesalers and dry goods stores, Philadelphians found luxury on fashionable lower Chestnut Street, one block south of Market Street. This stretch of stores on what was then called Chestnut Street was notable enough to be included in an 1856 collection of engravings, entitled "Panorama of Philadelphia." Rival jewelers Bailey & Co. (later Bailey, Banks & Biddle) and J.E. Caldwell & Co. occupied space at 136 and 140 Chestnut Street respectively.

12

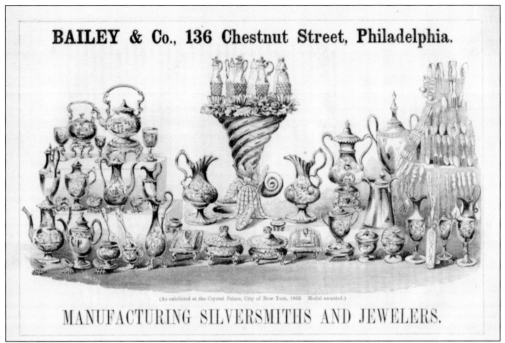

BAILEY & Co., 136 Chestnut Street, Philadelphia.

(As exhibited at the Crystal Palace, City of New York, 1853. Medal awarded.)

MANUFACTURING SILVERSMITHS AND JEWELERS.

Bailey & Co. was founded in 1832 as Bailey & Kitchen Jewelry Company. It was first located at what was then 136 Chestnut Street (now the Signers' Garden at the southeast corner of Fifth and Chestnut Streets). Bailey & Co. manufactured and sold its own lines of jewelry and silver goods as seen in this advertisement, which predates the store's 1859 move west to the 800 block of Chestnut Street.

The 1926 book *City of Firsts* notes that James E. Caldwell started his watch and jewelry business in 1835, but official store histories give the founding year as 1839. This advertisement dates to before 1858, when the store moved west from 140 Chestnut Street to a beautiful marble-fronted building at 822 Chestnut Street (see page 15). A year later, its rival Bailey & Co. would follow it west, moving directly across the street to 819 Chestnut Street.

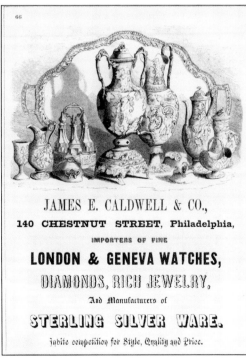

JAMES E. CALDWELL & CO.,
140 CHESTNUT STREET, Philadelphia,
IMPORTERS OF FINE
LONDON & GENEVA WATCHES,
DIAMONDS, RICH JEWELRY,
And Manufacturers of
STERLING SILVER WARE.
Invite competition for Style, Quality and Price.

13

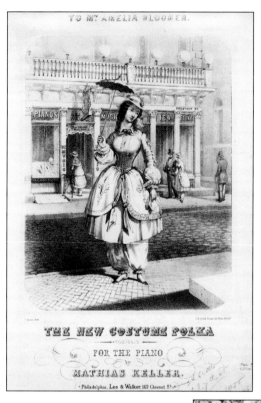

The elegance of mid-19th-century Chestnut Street can be seen on sheet music sold in the 1850s by the Lee & Walker music store, near the southeast corner of Eighth and Chestnut Streets. The song celebrates the short-lived fashion for women's bloomers, baggy trousers worn beneath a short skirt that were less restricting than hoop skirts. Popular among early feminists (who called it a "reform costume"), bloomers were a source of amusement or ridicule to most proper Philadelphians. (PPC/FLOP.)

J.E. Caldwell & Co. was located next door to Philadelphia's premier hostelry, the Continental Hotel at 824 Chestnut Street. As with many five-star hotels today, during a stay at the Continental one could shop for luxury items, including the latest style in men's suits. This engraving shows the handsome interior of Chas. Stokes & Co.'s One-Price Clothing Store in the hotel around 1860. (PPC/FLOP.)

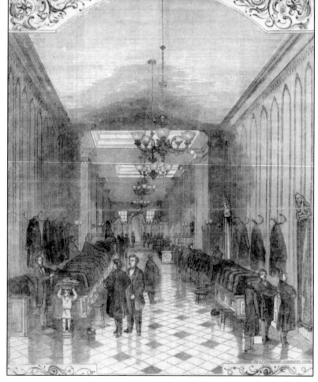

Two

JOHN WANAMAKER'S
NEW KIND OF STORE

Shortly after the death of his partner Nathan Brown in 1868, John Wanamaker opened a second store at 818–820 Chestnut Street, where he did business as John Wanamaker & Co. For Wanamaker, expanding onto the more upscale Chestnut Street was a prestige move. To the right of Wanamaker & Co. is the elegant marble facade of 822 Chestnut Street, home of J.E. Caldwell & Co. Jewelers until their move to 902 Chestnut Street in 1868. (Bruce Conner.)

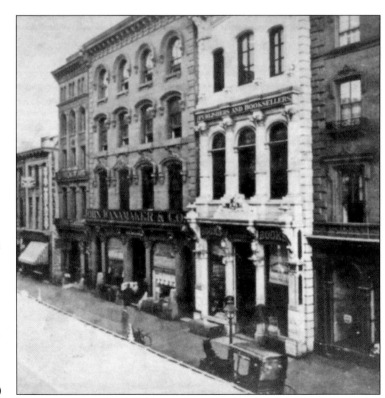

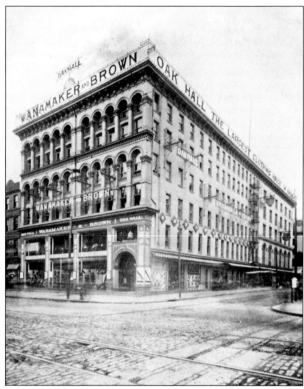

Before his business was 10 years old, Wanamaker expanded the original Oak Hall into the adjacent buildings, giving his new 67-foot front on Market Street a unified facade in the then popular Italianate style. Already one of the tallest structures on Market Street, the building's wraparound rooftop sign made it clear that shoppers were entering "Oak Hall—The Largest Clothing House in America."

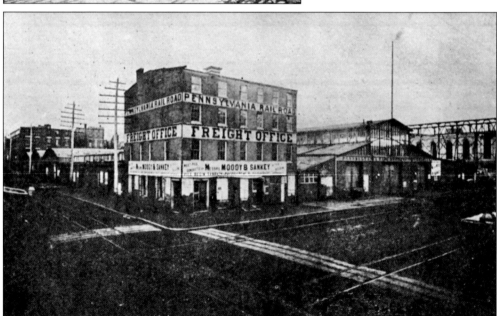

Wanamaker knew that, even with his branch store on Chestnut Street and the expansion of Oak Hall, he would soon need more space to fulfill his vision. In 1874, he purchased the dilapidated Pennsylvania Railroad freight depot at Thirteenth and Market Streets. The vast depot faced Penn Square on its west side where construction on Philadelphia's City Hall had begun in 1871. Wanamaker's purchase would prove to be a prescient one.

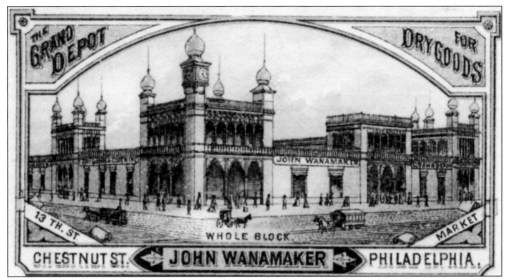

In May 1876, Wanamaker unveiled his "New Kind of Store" in the Grand Depot. Opening almost simultaneously with the Centennial Exhibition, the former freight depot was a wonder to behold and was often dubbed the "Centennial Annex." With its fanciful Venetian Gothic pavilions, Middle Eastern minarets, two acres of fully stocked selling space, and even a restaurant, the Grand Depot awed many of the fair's 10 million visitors.

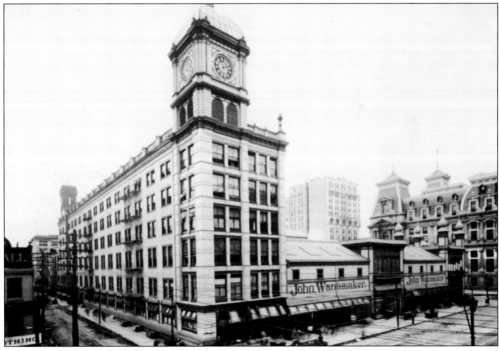

By 1877, Wanamaker had expanded his original men's clothing business to include dry goods and assorted ladies' ready-made items. In 1888, a new six-story building, designed by noted Philadelphia architect Theophilus P. Chandler, opened at the corner of Thirteenth and Market Streets. With its impressive clock tower, the Chandler Building replaced the eastern portion of the original depot and provided Wanamaker with much needed room for expansion.

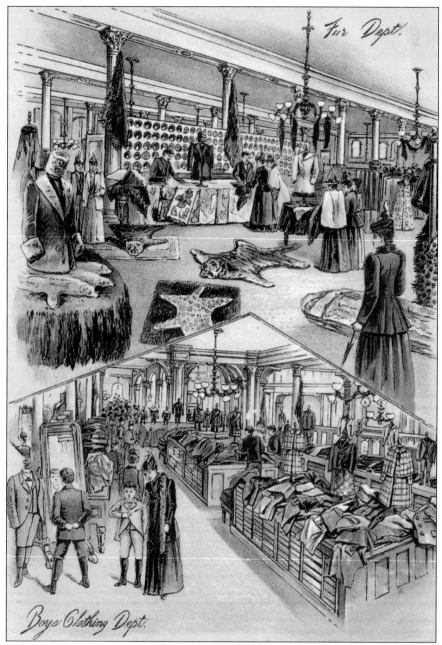

Wanamaker's new building not only provided additional space for the store's 47 departments and 3,200 employees, but its upper floors also allowed Wanamaker to manufacture his own mattresses and other merchandise. In-house production was deemed necessary when Wanamaker discovered that even the best mattresses purchased from outside wholesalers did not meet his rigorous standards of quality. This illustration, from a store brochure of the period, shows customers the large variety of goods to be found in the boys' department as well as the exotic wonders that awaited them in the lavish fur department. The fur business was so brisk in January 1896 that "$224,000 worth of furs was placed on sale at one time," which is $6 million in today's dollars (adjusted for inflation).

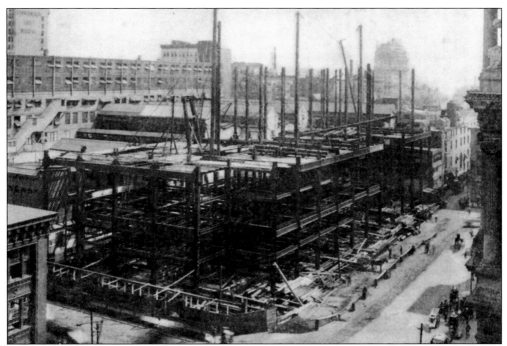

As the 19th century closed, John Wanamaker prepared to welcome the 20th with a bang, hiring Chicago architect Daniel H. Burnham to design a magnificent new palace of commerce. The caption to this 1904 image reads, "To construct a new twelve-story steel building while carrying on, without interruption, the largest retail business in the world on the same site . . . is the task which John Wanamaker is successfully accomplishing in Philadelphia." (PPC/FLOP.)

In February 1902, ground was broken at Market and Juniper Streets for the first part of the unified structure that would replace Wanamaker's complex of 19th-century buildings. As the new store rose in sections, business was shifted to the surviving older sections so that not one sales day was lost. This view shows the last portion of the old store along Chestnut Street before it was demolished in September 1908.

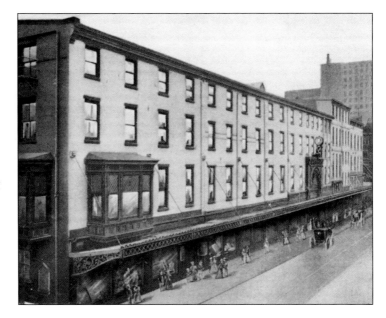

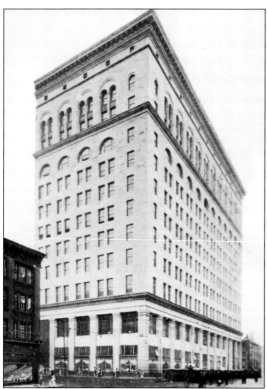

Here is the first quarter of the store as it appeared when completed in 1906. The building would ultimately be finished by June 11, 1910, in time to celebrate the 50th anniversary of the founding of Wanamaker and Brown in 1911. The jubilee year ended officially with the Address of Dedication delivered by Pres. William H. Taft in the Grand Court on December 30, 1911. (PPC/FLOP.)

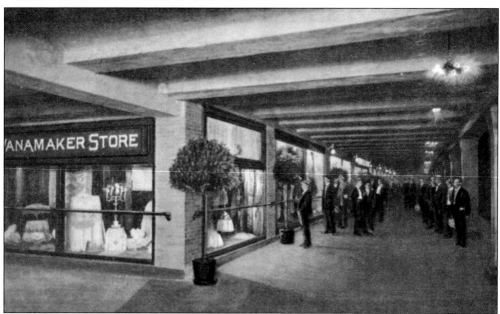

In 1908, the newly formed Philadelphia Rapid Transit Company officially opened the Market Street Subway, part of a underground-elevated transit line running from the Delaware River to Sixty-ninth Street in Upper Darby. Shoppers were able to leave the subway at the Thirteenth Street Station and stroll directly into the new Wanamaker store. An Eighth Street station provided access to Strawbridge & Clothier, Lits, and Gimbels. (Robert Morris Skaler.)

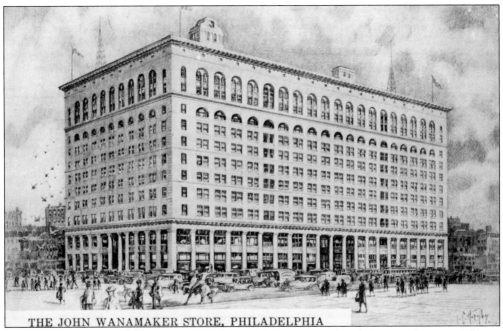

THE JOHN WANAMAKER STORE, PHILADELPHIA

With nearly 45 acres of floor space spread over 12 aboveground and three underground floors, the Wanamaker Store of 1911 was an architectural marvel. Its heart was a soaring Grand Court, which rose six stories from the main sales floor. Thanks to its exterior mantle of Maine granite over a steel skeleton, the store was essentially fireproof.

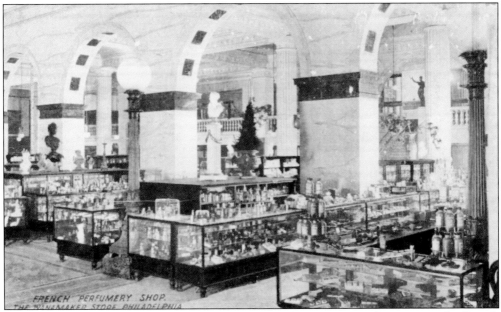

FRENCH PERFUMERY SHOP.
THE WANAMAKER STORE PHILADELPHIA

Amid the white and green marble arches of Wanamaker's new Grand Court was the French Perfumery Shop. Keenly aware of his upscale customers' attraction to all things French, Wanamaker opened a buying office in Paris in early 1880. Imports from France were not limited to fashions and perfumes. Wanamaker's also carried fine assortments of French art, antiques, tapestries and books.

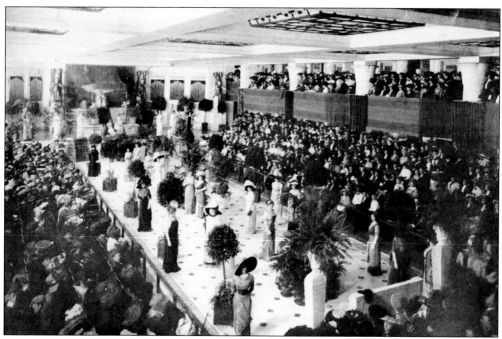

John Wanamaker intended his store to be a public meeting place, educational facility, and entertainment venue as well as a retail establishment. He made sure that several meeting rooms and auditoria were included in the building for lectures, concerts, and fashion shows. This image shows one of the two auditoria, Egyptian Hall, packed for an October 1910 exhibition of Paris "Gowns, Wraps and Costumes. Posed on American Women."

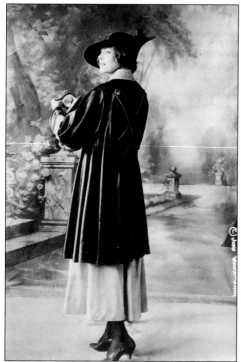

Here, one of Wanamaker's own fashion photographers captured this anonymous American woman modeling the latest French fashion for autumn of 1915. At that time, shopping for fine clothing would have been a much more personal and leisurely experience than it is today. In the many intimate fashion salons throughout the store, Wanamaker's could give its customers the feeling of shopping at a fine Paris couturier without ever having to leave Philadelphia. (Bruce Conner.)

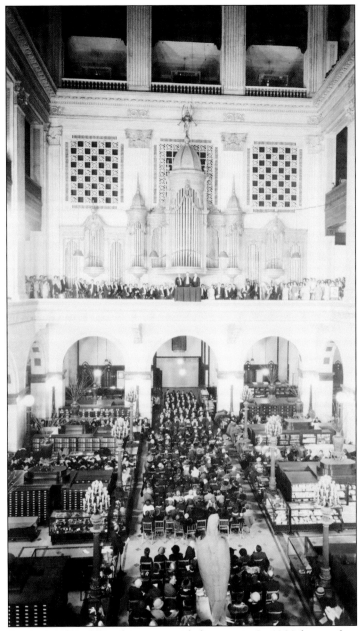

John Wanamaker insisted on filling his stores with fine music. In 1909, he purchased what would become the world's largest pipe organ. Originally built for the St. Louis World's Fair of 1904, it was shipped to Philadelphia by rail in 11 freight cars and installed in Wanamaker's new store in time for its dedication in 1911. This musical tradition continued after Wanamaker's son Rodman took over the store in 1922. During the 1920s, the Grand Court hosted regular Musicians' Assemblies, which featured the Philadelphia Orchestra under Leopold Stokowski as well as many world-renowned organists. This photograph shows Italian organ virtuoso and composer Marco Enrico Bossi after a concert performance of his work *Paradise Lost* in February 1925. A work for organ, orchestra, and voices, *Paradise Lost* featured organist Melchiore Mauro-Cottone, 50 members of the Philadelphia Orchestra, a chorus, and a double mixed quartet and soloists. (PPC/FLOP.)

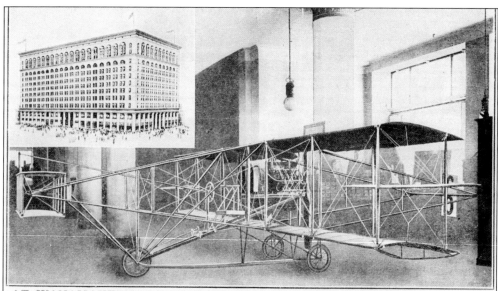

AT WANAMAKER'S, TO-DAY, WE SAW THE HERRING-CURTISS FLYING MACHINE THAT WON THE WORLD'S CHAMPIONSHIP AT RHEIMS, FRANCE, MAKING A SPEED OF ABOUT 46 MILES AN HOUR. THIS CERTAINLY IS FLYING!

CONQUERORS
OF THE
NORTH POLE

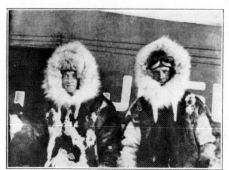

Photo Courtesy Pathe News-Times Wide World

LIEUTENANT COMMANDER R. E. BYRD, U. S. N.
AVIATION PILOT FLOYD BENNETT, U. S. N.

A BRIEF STORY OF THIS EPOCH MAKING FLIGHT, WITH A DESCRIPTION OF THE AIRPLANE WHICH MADE POSSIBLE THE FIRST CARRYING OF THE UNITED STATES FLAG TO THE NORTH POLE BY AIR

Compliments of
JOHN WANAMAKER PHILADELPHIA

Before movies, television, and jet planes, one way to experience adventure and innovation was to go to Wanamaker's. In August 1909, the American-manned Herring-Curtiss Flying Machine won first prize for speed at an international flying competition in Rheims, France. Shortly thereafter the winning flying machine was on display at Wanamaker's. (Bruce Conner.)

Several years later, John Wanamaker's son Rodman Wanamaker was able to acquire US Navy lieutenant commander Richard E. Byrd's Fokker Three Wright Engined airliner for a special exhibition for display from the US Navy, honoring Byrd's epic 1926 journey to the North Pole. The exhibition included not only the actual plane but also artifacts like Mukluks and skis used by US Navy aviation pilot Floyd Bennett.

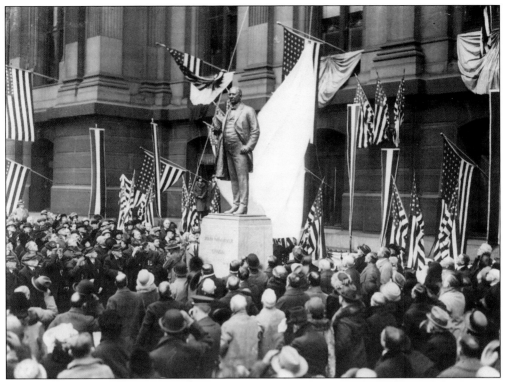

Within a year of his death on December 12, 1922, a larger-than-life bronze statue of John Wanamaker was erected on the east side of Philadelphia City Hall, facing his store. This rare photograph shows the moment of the unveiling on Thanksgiving Day on November 29, 1923. Among the large crowd gathered for the event was Philadelphia mayor J. Hampton Moore, conductor Leopold Stokowski (leading the Police Band of Philadelphia), and a delegation of Civil War veterans whom Wanamaker might well have outfitted back in 1861.

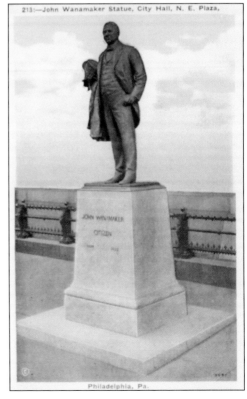

213:—John Wanamaker Statue, City Hall, N. E. Plaza,

Philadelphia, Pa.

Shortly after its unveiling, the statue of John Wanamaker became a favorite subject for postcards. However, some publishers clearly felt that the building behind the statue was too distracting. So, as seen in this early example of Photoshopping, the largest freestanding masonry structure in the world was blotted out and replaced by a brilliant blue sky.

It is hard to believe that the largest store in the world could ever outgrow its space, but that is exactly what had happened by the early 1930s. In the midst of the Great Depression, Wanamaker's built the 27-story Lincoln-Liberty Building on the northeast corner of Broad and Chestnut Streets. Catering mostly to male customers, the lower floors housed the London Shop for men and the Sportsmen's Concourse, while the upper floors were occupied by offices.

In the tower of the new building hung the 17¼-ton Founder's Bell, commissioned in 1926 by Rodman Wanamaker to honor both his late father and the sesquicentennial of the United States. Moved from its original home atop the main store in 1932, the bell still tolls today, striking every 15 minutes from 9:00 a.m. to 9:00 p.m. daily, except on Sundays and holidays.

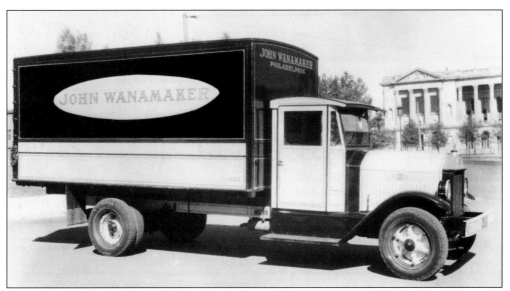

A store's delivery service not only cemented the bond between retailer and customer but also served as advertising. In 1911, Wanamaker's Philadelphia delivery service maintained over 300 horses to power its wagons. Wanamaker was also a pioneer in the use of "commercial automobiles," with 67 trucks serving Philadelphia and New York daily. This elegant truck is an American LaFrance, shown on Logan Square around 1928. (PPC/FLOP.)

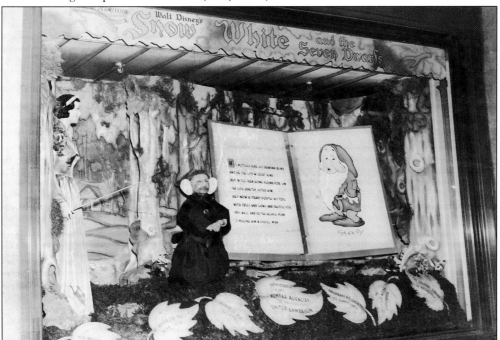

Department stores also enticed customers through elaborate window displays. This Wanamaker's Men's Store window was sponsored by the Member Agencies of the United Campaign and probably coincided with the 1944 rerelease of Disney's 1937 Snow White and the Seven Dwarfs. It featured a somewhat scary live little person disguised as Dopey turning the pages of a huge book that told tales of children helped by the Member Agencies. (PPC/FLOP.)

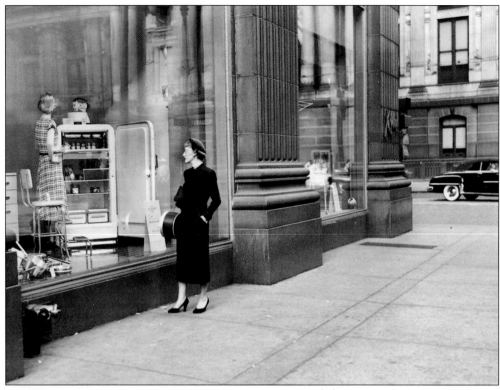

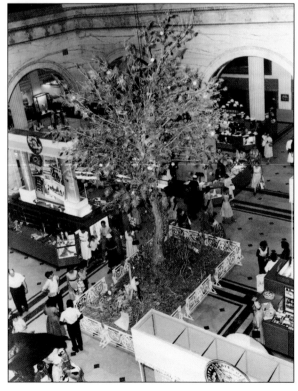

While Wanamaker's store windows were exotic and elaborate during the holidays and other special occasions, they could be more prosaic during the off-season, as shown by the banal kitchen display in this enigmatic 1951 shot. Is the window shopper at right—who seems like a successful career woman with her chic black dress and hatbox—debating the virtues of domestic life as a suburban wife and mother? (PPC/FLOP.)

Wanamaker's display team rarely failed to wow customers when it came to decorating the Grand Court, even for minor events. Seen here is the amazing "Money Tree" erected for the Summer Dividends Sale in June 1957. This photograph is also notable for the presence of African American customers, an indication of the gradual desegregation of Philadelphia society in the postwar period. (PPC/FLOP.)

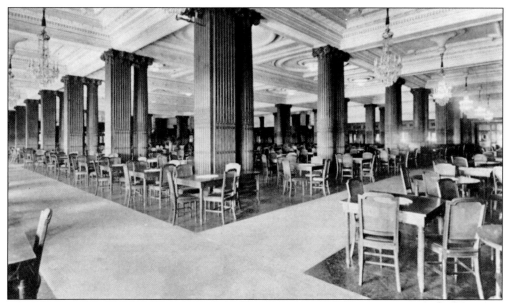

John Wanamaker always included a place in his stores where his customers could take refreshment. While his original Dairy restaurant was a small affair in the basement of the Grand Depot, Wanamaker's new store was crowned by the elegant, oak-paneled Great Crystal Tea Room, which opened on the eighth floor in 1911 (above). Covering 22,000 square feet, the Great Crystal Tea Room could serve up to 1,400 guests at a time. At either end of the tearoom were smaller, more private dining venues, such as the Men's Grill, La Fontaine, the Terrace Restaurant (below), and Le Coin Rose. The Terrace Restaurant would eventually be relocated to the store's third floor, overlooking the Grand Court, the organ, and the store's iconic bronze eagle. The Crystal Tea Room closed in 1995 and is now used as a private banqueting facility.

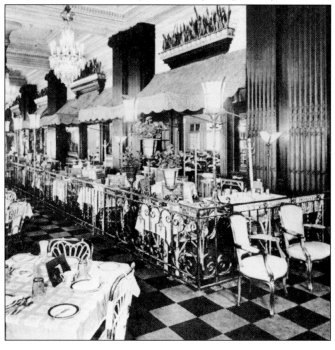

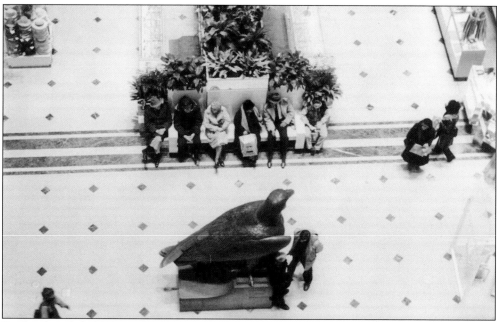

To this day, Philadelphians know that they can easily meet friends, family, or business associates at the great bronze eagle steps away from the geographical center of Philadelphia (above). Like the great organ, the eagle was purchased by John Wanamaker from the 1904 St. Louis World's Fair and has been a fixture in the Grand Court since the store's opening. Created by German sculptor August Gaul, the eagle weighs 2,500 pounds and sits atop a 4,500-pound granite pedestal. From the beginning, the eagle was a tourist attraction and appeared not just in advertising, but also on postcards, men's ties, cuff links, scarves, and souvenir handkerchiefs. This "Meet Me at the Eagle" linen handkerchief (below) was designed especially for Wanamaker's in the 1950s by noted textile designer Tammis Keefe. (Both, Anne Swoyer.)

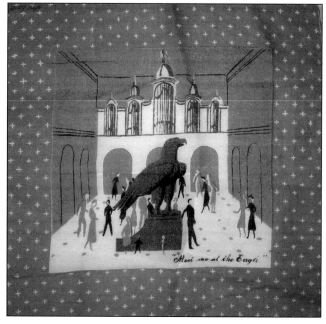

Three

STRAWBRIDGE & CLOTHIER

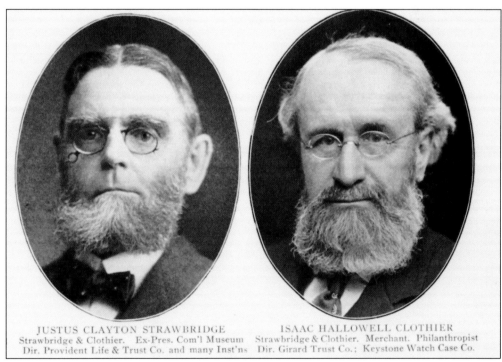

JUSTUS CLAYTON STRAWBRIDGE
Strawbridge & Clothier. Ex-Pres. Com'l Museum
Dir. Provident Life & Trust Co. and many Inst'ns

ISAAC HALLOWELL CLOTHIER
Strawbridge & Clothier. Merchant. Philanthropist
Dir. Girard Trust Co.; Keystone Watch Case Co.

On July 1, 1868, two Quaker merchants named Justus C. Strawbridge and Isaac H. Clothier founded the Strawbridge & Clothier dry goods business in Strawbridge's store at Eighth and Market Streets (see page 11). By 1900, when these photographs appeared in King's *Philadelphia and Notable Philadelphians*, the two merchants had become wealthy and respected civic leaders. Despite its growth, Strawbridge & Clothier reflected its founders' Quaker values and gentility. It was "the comfortable store" that called its customers "visitors" and remained closed on the First Day long after other stores adopted Sunday hours. And while other stores had a bargain basement, Strawbridge & Clothier offered the Fashion Basement.

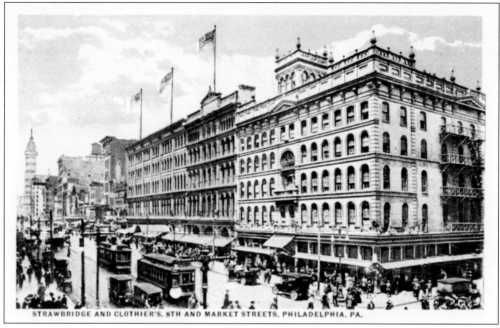

STRAWBRIDGE AND CLOTHIER'S, 8TH AND MARKET STREETS, PHILADELPHIA, PA.

During the late 19th century, Strawbridge & Clothier steadily expanded its presence on Market Street. Its original home was soon replaced by a modern five-story building, which was enlarged and expanded several times. Strawbridge & Clothier also acquired other structures farther west on Market Street. By the time this postcard was issued around 1900, the store occupied most of the block bordered by Market, Filbert, Eighth, and Ninth Streets.

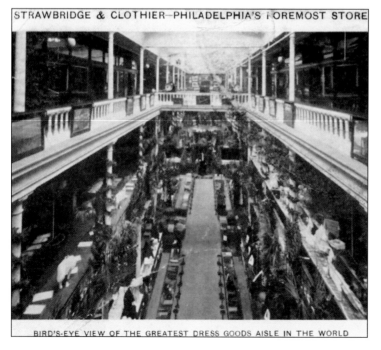

STRAWBRIDGE & CLOTHIER—PHILADELPHIA'S FOREMOST STORE

BIRD'S-EYE VIEW OF THE GREATEST DRESS GOODS AISLE IN THE WORLD

Advertising itself as "the largest store in the United States devoted exclusively to dry goods," Strawbridge & Clothier sold a bewildering array of merchandise. In this c. 1900 postcard, the bottom gallery is devoted to women's clothing while the top two floors are packed with home furnishings and decor. The primitive electrical lighting of the period made large skylights and open atria necessary features of department store architecture.

Quaker Strawbridge & Clothier showed its worldly side during the annual *Fête de Printemps* and *Fête d'Automne*, when the store blossomed with the latest Parisian fashions. This postcard shows the atrium decorated for the 1912 *Fête d'Automne*. At the bottom is the store's Seal of Confidence, showing William Penn concluding a treaty with the chief of the Lenni-Lenape. Adopted in 1911, this seal illustrated the trust the store strove to maintain with its loyal customers. (Robert Morris Skaler.)

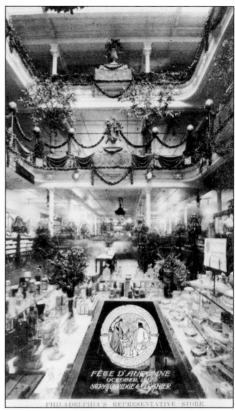

In July 1907, thousands of members of the Benevolent Paternal Order of Elks descended upon Philadelphia for their annual convention. Market Street went wild decorating itself to attract the conventioneers and their wives. Strawbridge & Clothier's facade was hidden behind purple-and-white bunting and lights (the colors of the fraternal order), plaster elks, and an Art Nouveau welcome sign adorned with a clock and elk's head. (James Hill Jr.)

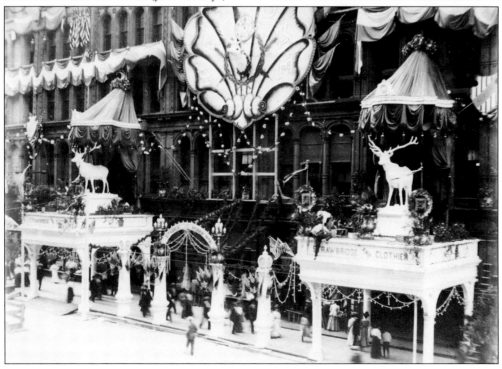

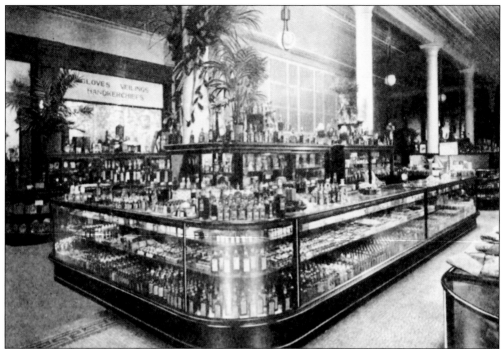

These postcards show the sober, everyday face of Strawbridge & Clothier around 1915, portraying its perfumery (above) and furniture store (below). While Strawbridge & Clothier may have lacked the chic of Wanamaker's, the Quaker store was synonymous with solid, dependable quality. It prided itself on being a place where a woman customer in 1911 could ask for a white starched blouse, "such as I bought twenty years ago." But after the completion of the new Wanamaker store that same year, Strawbridge & Clothier grew concerned that its amalgamation of 19th-century structures was too antiquated. These concerns increased as the store began to lag behind its competitors in sales after World War I. In 1923, store president Francis Strawbridge consulted an architect about rebuilding part of the store as an entirely new building. (Both, James Hill Jr.)

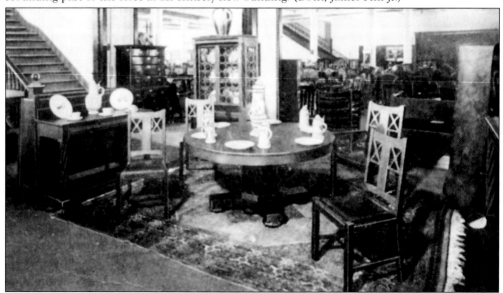

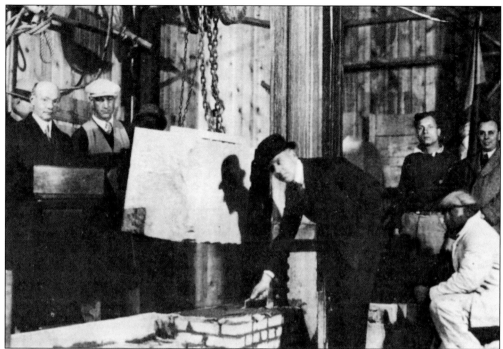

After years of discussion and debate, the cornerstone was laid for a new Strawbridge & Clothier store on April 21, 1930. The building would stand at the store's original location on the northwest corner of Market and Eighth Streets. In the photograph above, vice president Robert E. Strawbridge seals the cornerstone, using a special gold trowel, while store president Dr. H.J. Tily stands at left. The cornerstone contained a time capsule that held local newspapers, currency from the Philadelphia Mint, a Bible, William Penn's *Some Fruits of Solitude*, a medallion of Pres. Herbert Hoover, store publications and memorabilia, and "samples of silk, cotton, and linen, shoes, stockings, and even jewelry typical of 1930 fashions" (below). At this point, only six months after the stock market crash of October 1929, no one could anticipate how painful the ensuing Depression would be.

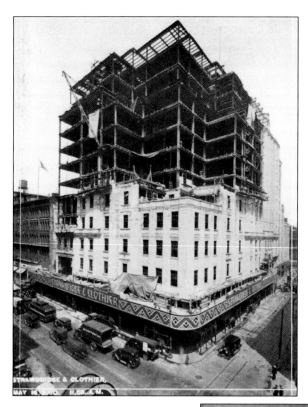

By spring 1930, the new store's steel skeleton had been erected and its exterior completed up to the fourth floor. Designed by Simon & Simon, the granite-and-limestone structure offered an Art Moderne profile broken by dramatic setbacks. The 13-story building was the first Philadelphia department store to feature air-conditioning. By staggering the construction of various sections of the building, Strawbridge & Clothier could continue business uninterrupted, even when a fire in July 1930 caused $1 million in damage.

Although still under construction, the new store was inaugurated with a weeklong sale in November 1930, which was profitable enough to allow Strawbridge & Clothier to finish the year ahead of its competitors. But as the Depression deepened, the costs of the new structure (over $10 million), plus the expenses of new branches in Ardmore and Jenkintown, weighed on the company's bottom line. Shortly after the Center City store was completed in October 1931, Strawbridge & Clothier suspended stock dividends.

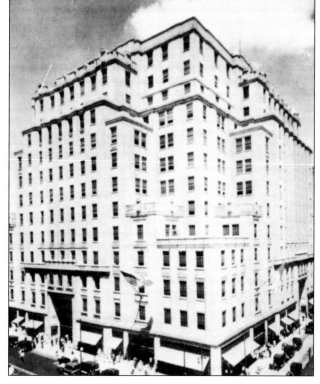

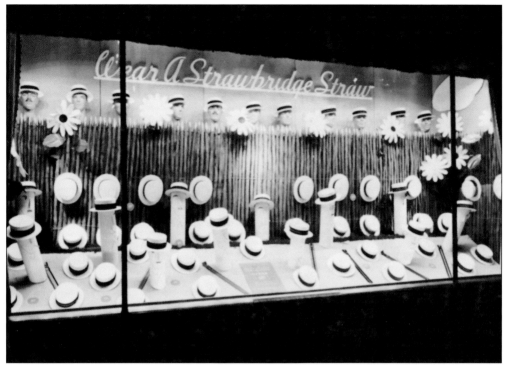

This jaunty window from the late 1930s, encouraging Philadelphia gentlemen to sport a Strawbridge & Clothier straw boater, reflects the store's improving financial condition as the decade progressed. During this period, the store was the first in Philadelphia and only the third in America to introduce the Charga-Plate, an early store credit card. By 1936, Strawbridge & Clothier was able to resume paying dividends on its stock. (PPC/FLOP.)

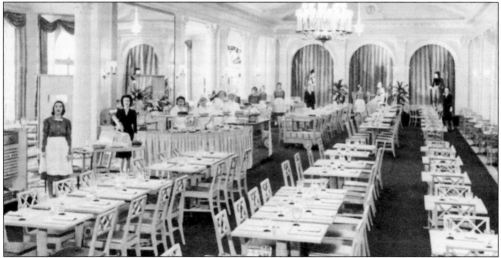

Opened in August 1942, the sixth-floor Corinthian Room was Strawbridge & Clothier's answer to Wanamaker's Crystal Tea Room. Nearby, the oak-paneled Pickwick Grill offered a heartier retreat for male shoppers and executives, while the Old Philadelphia Lunch Room in the Fashion Basement provided a more casual dining experience. In 1982, the store opened a Balcony Café, part of an 8,500-square-foot Food Hall that offered gourmet goodies to go. (James Hill Jr.)

In 1956, *Store Chat*, the Strawbridge & Clothier employee magazine, celebrated the 50th anniversary of Clover Days. Designed to attract customers during slow selling periods, the first Clover Day in 1906 offered many goods at half-price, marked by four-leaf clovers. The popular sale would lend its name to a 26-store chain of discount outlets, Clover Stores, the first of which opened in 1971. (Mr. and Mrs. Francis R. Strawbridge III.)

In 1966, Strawbridge & Clothier staged an *Italia Bravissima* Fair. After the fair ended, a reproduction of *Il Porcellino*, a bronze boar that has guarded the Mercato Nuovo in Florence since 1612, became a permanent resident of the store. As with the original, rubbing the snout of *Il Porcellino* was supposed to bring good luck. (Mr. and Mrs. Francis R. Strawbridge III.)

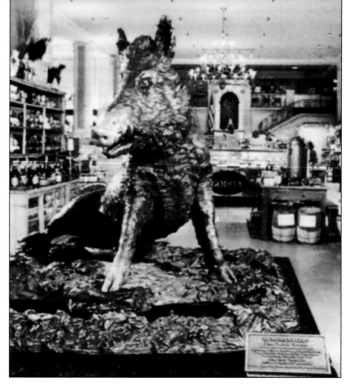

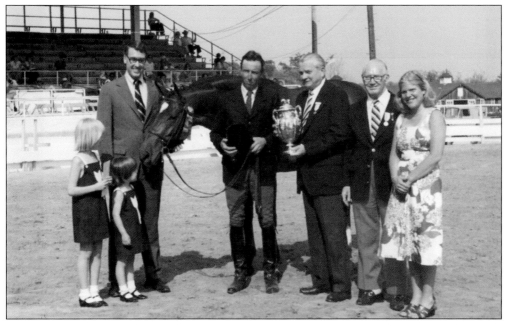

With a number of avid equestrians in both clans, the Strawbridge and Clothier families have been longtime supporters of the Devon Horse Show, one of the country's oldest and most prestigious outdoor horse shows. Longtime store president Isaac H. Clothier Jr. (1876–1961) ran the show for many years. At the 1978 Devon Horse Show (above), members of the Strawbridge and Clothier families, including Francis R. Strawbridge III and his daughters Lynn and Meg (at left) and Melinda Clothier (at right), assisted in the presentation of the Devon Challenge Trophy. Below, attendees relaxed outside a booth operated by employees of Strawbridge & Clothier's Ardmore Store, named "Annie's Hall Closet" after the award-winning Woody Allen film. (Above, Mr. and Mrs. Francis R. Strawbridge III.)

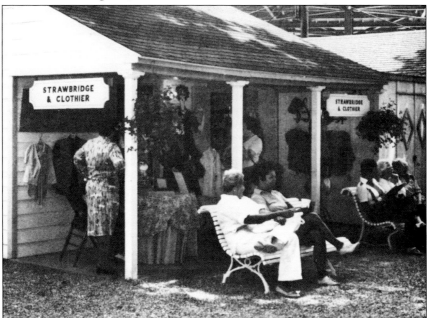

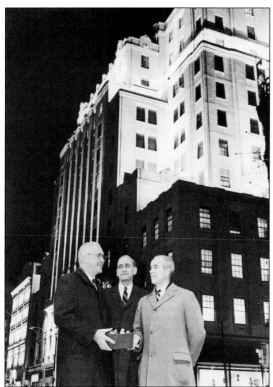

On February 7, 1968, Strawbridge & Clothier celebrated its 100th anniversary. Store chairman G. Stockton Strawbridge (right) and president Randall E. Copeland (center) joined forces with Mayor James H. Tate (left) to illuminate the main store with over 600 lights. But sales at the main store were dropping due to the deteriorating ambience of Center City. G. Stockton Strawbridge would become a leader in the movement to rehabilitate Market Street East. (PPC/FLOP.)

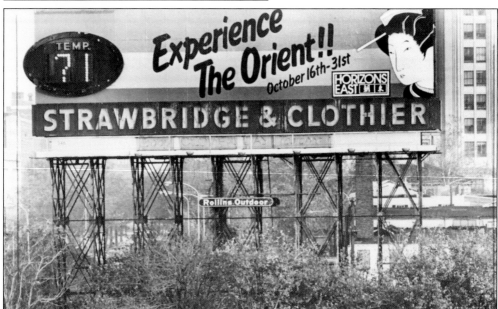

For years, the Strawbridge & Clothier billboard near the Schuylkill River was a familiar sight to drivers on the Vine Street and Schuylkill Expressways. In October 1981, the billboard promoted Horizons East, an extravaganza of Far Eastern culture, arts, and goods. Among the attractions were a tapestry of the Great Wall of China, costumes from the Peking Opera, and experts demonstrating origami, calligraphy, and kite making. (TUL/UA.)

Four

NOBODY BUT NOBODY UNDERSELLS GIMBELS

Although the Gimbel Brothers Department Store (or "Gimbels") was born in the Midwest, it blossomed after it moved to Philadelphia in 1894 and went on to become a beloved local institution. In 1835, 20-year-old Adam Gimbel emigrated from Bavaria to New Orleans with $5 in his pocket. Seven years later, Adam opened a "Palace of Trade" (an elegant moniker for a dry goods store) in Vincennes, Indiana. In 1887, Adam's seven surviving adult sons—Jacob, Isaac, Daniel, Charles, Ellis, Benedict, and Louis—opened the first Gimbel Brothers store in Milwaukee, Wisconsin.

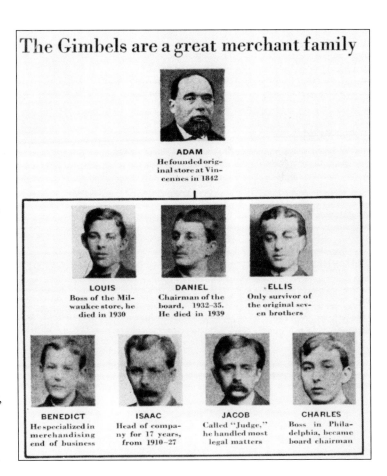

The Gimbels are a great merchant family

ADAM
He founded original store at Vincennes in 1842

LOUIS
Boss of the Milwaukee store, he died in 1930

DANIEL
Chairman of the board, 1932–35. He died in 1939

ELLIS
Only survivor of the original seven brothers

BENEDICT
He specialized in merchandising end of business

ISAAC
Head of company for 17 years, from 1910–27

JACOB
Called "Judge," he handled most legal matters

CHARLES
Boss in Philadelphia, became board chairman

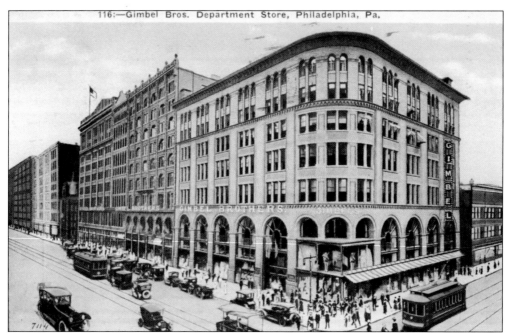

In 1894, the Gimbel Brothers moved to Philadelphia and acquired the Granville B. Haines & Co. store at the southeast corner of Market and Ninth Streets. The distinctive Haines Building had been designed by Addison Hutton in 1890 as the first structure to house a complete department store from the outset. But due to overspending, financial irregularities, and the Panic of 1893, the Haines business closed shortly after its new store opened.

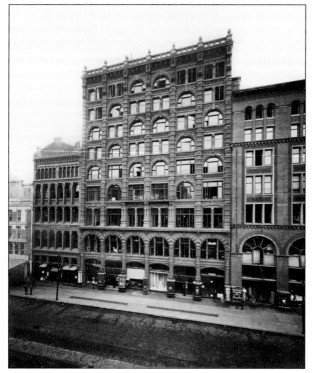

Throughout the 1890s, Gimbel Brothers acquired other properties on the south side of Market Street between Eighth and Ninth Streets, including the Sharpless Building (at left) and the Weightman Building (center). By 1900, when Francis Kimball designed the Gimbel Building at Eighth and Market Streets, Gimbel Brothers ran the length of Market between Eighth and Ninth Streets. At 23 acres, Gimbels called itself "the largest exclusively retail store in the world." (PPC/FLOP.)

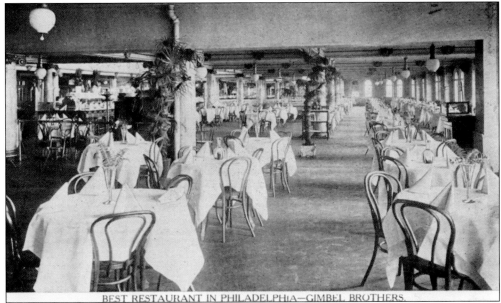

BEST RESTAURANT IN PHILADELPHIA—GIMBEL BROTHERS.

The expanded Gimbel Brothers held the middle ground between elite stores, such as Wanamaker's and Strawbridge & Clothier, and lower-priced stores, such as Lit Brothers and Snellenburg's. It offered a full-service restaurant on the seventh floor (above) and an extensive jewelry department (below) with treasures ranging from a $4 rhinestone pendant to a $950 diamond solitaire ring. Among Gimbels' other wonders were 1,000 telephones, a hospital with a trained nurse, and a bank that paid four-percent interest on savings. Brave shoppers could venture between floors on the first escalator ever to be installed in a department store (first displayed at the Paris Universal Exposition of 1900), while more cautious visitors could rely on the store's 38 elevators. In 1905, the period when these postcards were issued, the Gimbel Brothers relocated their company headquarters from Milwaukee to Philadelphia.

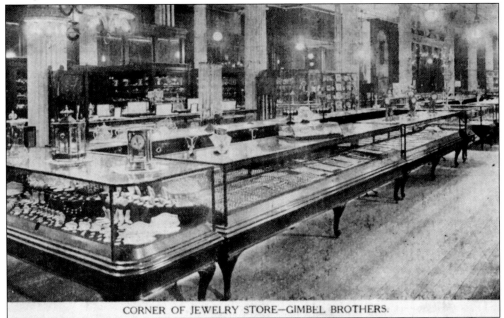

CORNER OF JEWELRY STORE—GIMBEL BROTHERS.

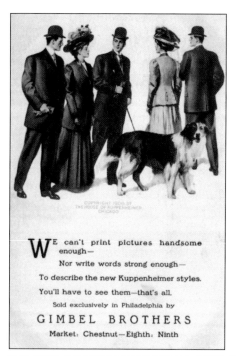

In the words of one early advertising slogan, "Nobody but nobody undersells Gimbels." From the start, Gimbels emphasized good value at low prices, as in this advertisement for Kuppenheimer Clothes. In the years before World War I, shoppers could buy $15 men's serge suits for $8.50 and $15 women's suits for $6.90. A chic ladies' Easter bonnet in black-and-white striped taffeta, trimmed with American Beauty roses and velvet ribbon and topped by three ostrich feathers, was offered for only $10.

WE can't print pictures handsome enough—

Nor write words strong enough—

To describe the new Kuppenheimer styles.

You'll have to see them—that's all.

Sold exclusively in Philadelphia by

GIMBEL BROTHERS
Market: Chestnut—Eighth: Ninth

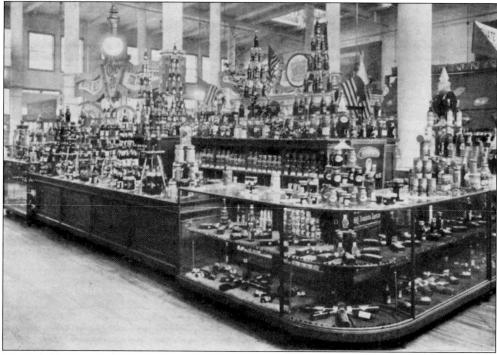

In 1906, Upton Sinclair's scathing exposé of the meatpacking industry, *The Jungle*, awakened Americans to the potential hazards of the food they consumed and led to the passage of a Pure Food and Drug Act. But three years before the act's passage, Gimbels had opened a "Pure Food" store, which was "big enough to guarantee purity, cleanliness and careful handling of food stuffs" at the "lowest obtainable prices."

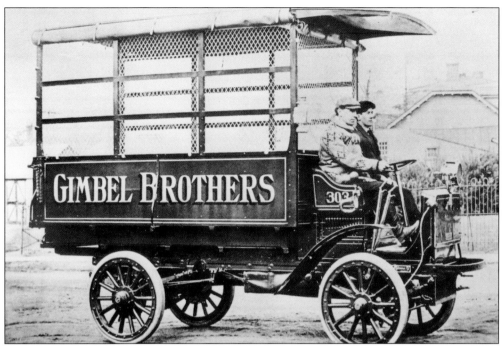

In 1896, Gimbels launched America's first motorized delivery wagon onto the streets of Philadelphia. Shown here is a 1907 Gimbels Autocar truck manufactured in Ardmore, Pennsylvania. By 1912, Gimbels' fleet consisted of over 100 electric and gasoline trucks serving the greater Philadelphia area. Another 128 vehicles delivered goods for its 27-acre Manhattan store, which had opened in 1910 on Herald Square, directly across Thirty-fourth Street from what would become its longtime rival, Macy's.

Like other Market Street stores, Gimbels supported the construction of the Market Street Subway and added a special underground entrance leading directly into its "Subway Store," as the bargain basement was called when it opened in 1912. To drum up business on a slow sales day, Gimbels declared Tuesdays to be "Subway Store Days" and added a soda fountain and quick lunch service in the basement to accommodate economy-minded customers.

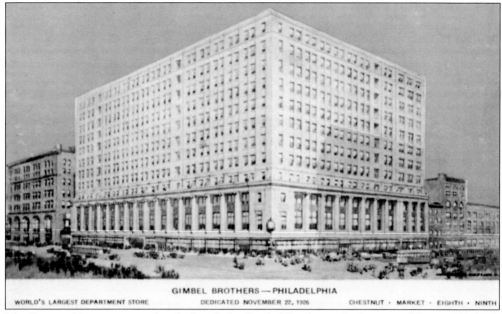

GIMBEL BROTHERS — PHILADELPHIA

WORLD'S LARGEST DEPARTMENT STORE DEDICATED NOVEMBER 22, 1926 CHESTNUT · MARKET · EIGHTH · NINTH

The Roaring Twenties were a heady decade for Gimbel Brothers, which went public in 1922 (with the Gimbel family maintaining a controlling interest). In 1923, the company acquired Saks & Co., a New York purveyor of luxury goods that was building a new Fifth Avenue emporium. The same year, Gimbels unveiled plans for a new $10 million, 15-story addition at Ninth and Chestnut Streets, adjacent to its original store.

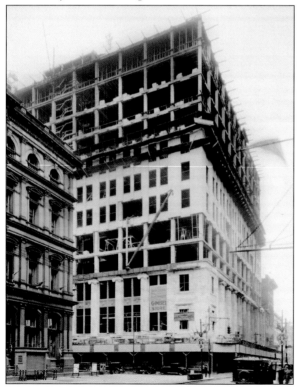

The Chestnut Street addition, shown here under construction in 1926, was designed by Graham, Anderson, Probst & White. While half of the building was leased for office space, its 17 additional acres of retail space made Gimbels the largest department store in the world once again. With its completion in 1927, Gimbels covered nearly the entire block bounded by Eighth, Market, Ninth, and Chestnut Streets, except for Leary's Book Store. (TUL/UA.)

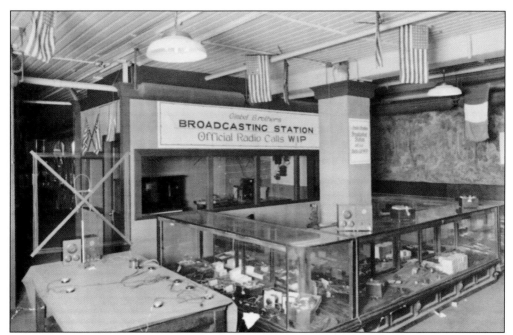

In March 1922, Gimbel Brothers inaugurated one of the first radio stations in Philadelphia, WIP (rumored to stand for "Wireless in Philadelphia"). The first studio was housed in the soundproof rooms used to sell phonograph records and pianos. WIP was the first local station to air a children's program, *Uncle WIP's Toyland*, and to broadcast a live football game. Sold in 1950, the station is today called CBS Sportsradio 610WIP. (TUL/UA.)

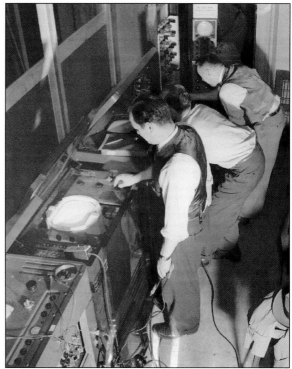

"For the first time ever! Shop by Television in Gimbels," trumpeted the newspaper advertisements in October 1945. That year, Gimbels teamed with RCA Victor to install an in-house television studio that broadcast commercials to monitors throughout the store. Here, RCA engineers supervise the installation of studio equipment. In 1946, local station WPTZ (Channel 3) broadcast *All Eyes on Gimbels*, the first fully sponsored television program. (TUL/UA.)

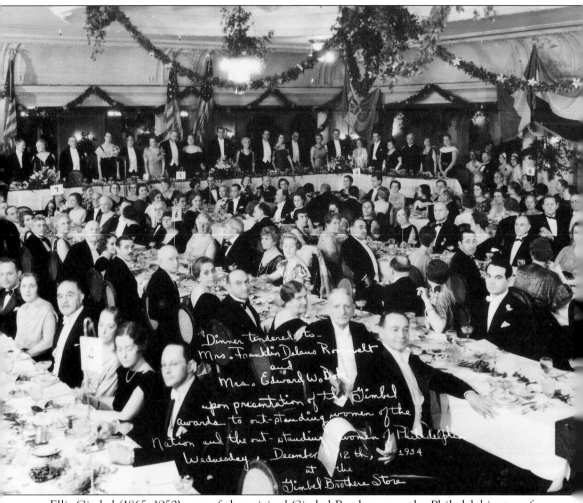

Ellis Gimbel (1865–1950), one of the original Gimbel Brothers, ran the Philadelphia store for decades and assumed the mantle of philanthropist and civic leader once worn by John Wanamaker. Beginning in 1915, he organized Orphans Day at the Circus, which treated over 10,000 children each year to the Ringling Brothers Circus. He was an early supporter of the Federation of Jewish Charities and cofounded the Philmont Country Club in 1906, when other suburban clubs refused to admit Jewish members. In 1932, he established the Gimbel Awards, conferred upon women in recognition of outstanding "service to humanity" on both the local and national levels. On December 12, 1934, the second Gimbel National Award was given to First Lady Eleanor Roosevelt. This photograph shows the award dinner at the Gimbel Brothers store. Roosevelt is standing between the American flags at the main table in the black and white dress with Ellis Gimbel to her right. Other recipients of the Gimbel Awards included anthropologist Margaret Mead, singer Marian Anderson, and aviator Amelia Earhart.

From September 8 until October 15, 1947, Gimbels hosted the Better Philadelphia Exhibition, created by city planner Edmund N. Bacon and architects Oskar Stonorov and Louis I. Kahn. The show called for attention to the need for urban planning and renewal in decrepit, postwar Philadelphia. Its highlight was a 30-foot-by-14-foot scale model of Center City (right) as it then appeared, with 45,000 buildings. Large sections of the model flipped over to reveal a reborn Philadelphia featuring many designs that later became reality, such as Society Hill, Penn Center, and Independence Mall. On the way out (below), a large sign asked visitors, "What kind of Philadelphia are you going to give your children?" In only five weeks, over 385,000 visitors viewed the Better Philadelphia Exhibition, which helped to generate an unstoppable momentum to recreate the city over the coming decades.

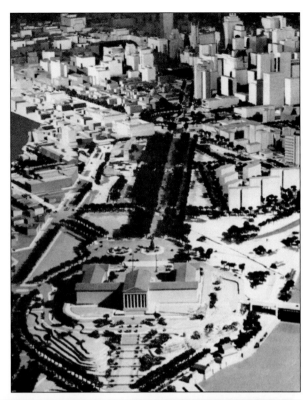

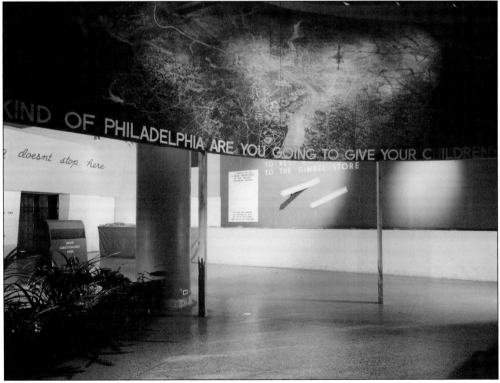

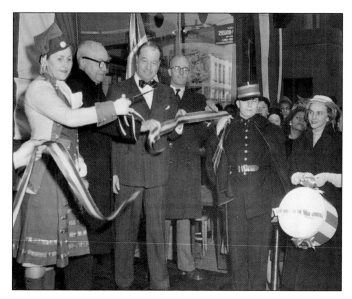

During World War II, Philadelphians bought over $2.5 million in war bonds and stamps at Gimbels, earning the store the nickname, "Gimbels Freedom Corner." The name was revived during the Cold War to help promote European imports. In March 1951, Mrs. Marshall Coyne cut the ribbon on a French-themed "Freedom Corner," watched by French consul Raoul Blondeau, Gimbels president Arthur C. Kaufmann, and Gaston Ponsart of the French Embassy. (TUL/UA.)

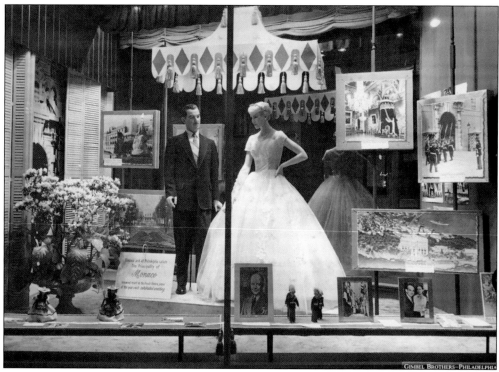

In April 1956, Philadelphia beamed with pride when 26-year-old East Falls native Grace Patricia Kelly, after a brief but brilliant career as an Oscar-winning Hollywood star, married Prince Rainier III of Monaco to become Her Serene Highness Princess Grace. Gimbels commemorated the event with a store window that displayed pictures of Monaco, dolls wearing Monégasque costumes, and two store mannequins with a passing resemblance to Rainier and Grace. (TUL/UA.)

Five

THRIFTY STORES FOR THRIFTY PEOPLE

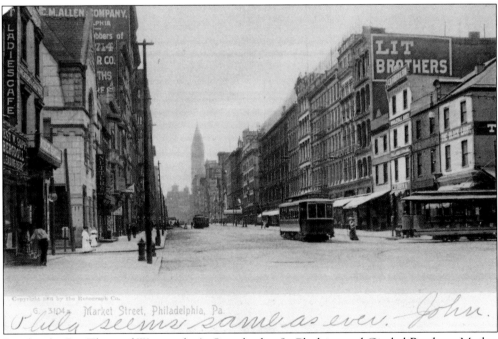

Besides the Big Three of Wanamaker's, Strawbridge & Clothier, and Gimbel Brothers, Market Street was home to many other department stores over the years. Lit Brothers, on the north side of Market between Eighth and Seventh Streets, and N. Snellenburg & Co., on the south side between Eleventh and Twelfth Streets, were two 19th-century institutions that survived well into the 20th century. Other stores had shorter lives, such as Partridge & Richardson, Joseph Darlington, Marks Brothers, Blauner's, H.L. Green, Stern's, and Frank & Seder. (Robert Morris Skaler.)

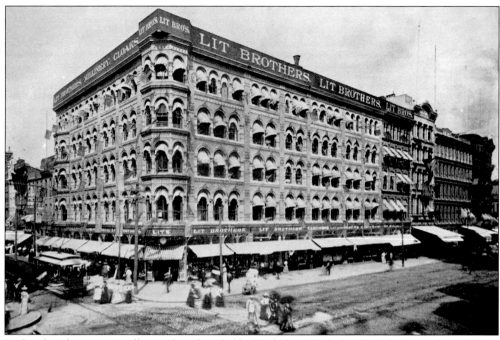

Lit Brothers began as a millinery shop founded by Rachel Lit Wedell on Eighth Street above Filbert in 1890, which thrived thanks to her offer to trim hats purchased at the store free of charge. In 1893, she was joined by brothers Samuel and Jacob Lit, who built a new store at the northeast corner of Eighth and Market Streets. Over the next decade, the Lit family acquired other stores along the block and added a new corner building at Seventh and Market Streets (above). In July 1907, Lit Brothers was gaily decorated to welcome the Elks to Philadelphia (below), just like its neighbor across Eighth Street, Strawbridge & Clothier. Besides plaster elks and purple-and-white bunting, Lits enticed the Elks with free use of the store's telephones and telegraph and vaudeville shows four times a day. (Robert Morris Skaler.)

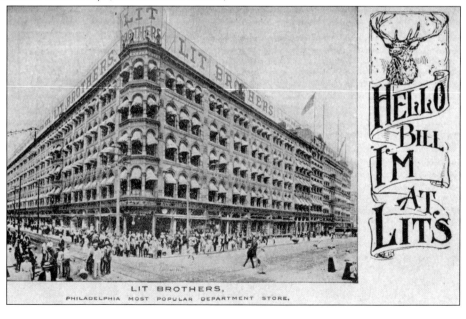

LIT BROTHERS,
PHILADELPHIA MOST POPULAR DEPARTMENT STORE.

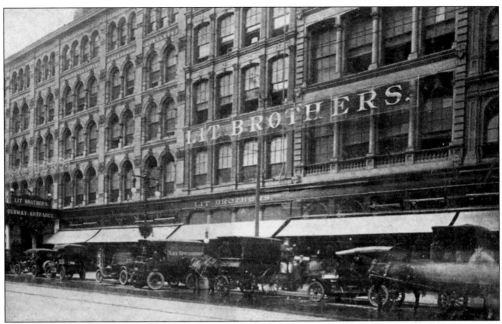

Like its competitors, Lit Brothers offered up-to-date amenities like a fleet of motorized delivery trucks (above) and a subway entrance that led directly to its bargain basement (below). By the time these photographs were taken in the early 20th century, Lit Brothers was promoting itself as "A Great Store in a Great City." Its flagship store, with over 15 acres of retail space, covered the entire block bounded by Eighth, Market, Ninth, and Filbert Streets. Lits also maintained factories around the city where it manufactured its own wares, along with two storehouses. In 1928, when the store was at the peak of its prosperity, the Lit family sold it to City Stores Company, a retail holding company that was part of Albert M. Greenfield's Bankers Securities Corporation, for $10.5 million. (Above, PPC/FLOP; below, Robert Morris Skaler.)

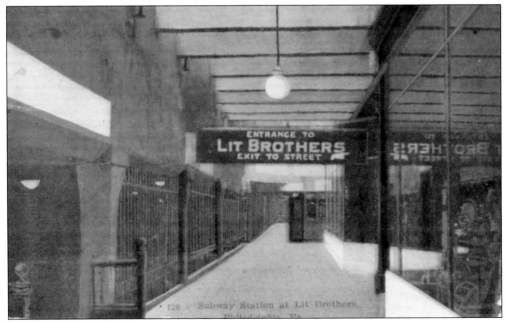

SPECIAL SALES FOR JULY

HOSIERY & UNDERWEAR	1914		July			1914		WAISTS
WEDNESDAY ①	Sun.	Mon.	Tue.	Wed.	Thu.	Fri.	Sat.	**THURSDAY ⑨**
MEN'S FURNISHINGS	Full Moon 7	Last Quar. 15	New Moon 22	❶	❷	3	4	HOUSE DRESSES & NEGLIGEES
THURSDAY ②	5	6	7	❽	❾	10	11	**WEDNESDAY ⑮**
	12	13	14	⑮	16	17	18	
UNDERMUSLINS	19	20	21	22	23	24	25	**HATS**
WEDNESDAY ⑧	26	27	28	29	30	31	First Quar. 29	TRIMMED FREE OF CHARGE

WRITE FOR PARTICULARS AND CATALOGUE OF ANY OF THESE SALES

Like Gimbels, Lit Brothers specialized in sales that brought shoppers into the store during slow periods, like the summer or mid-week. This giveaway ink blotter shows the special sales days during July 1914, just before the outbreak of war in Europe. At the bottom right is Lits' perennial promise, "Hats trimmed free of charge," which still appears on the building's marquees.

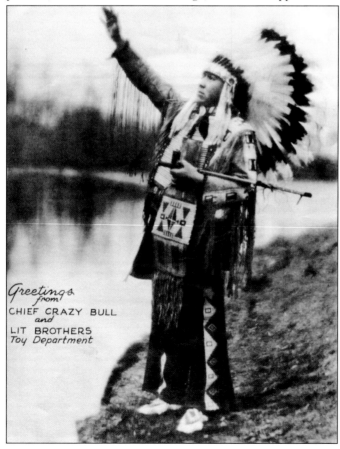

Greetings from CHIEF CRAZY BULL and LIT BROTHERS Toy Department

Chief Crazy Bull (1901–1952), seen here in this c. 1935 publicity shot, was one of many special attractions Lits used to promote its toy department during the holidays. Also known as William Jacobs, Crazy Bull was a full-blooded Sioux chief and the grandson of Sitting Bull, who once toured with Buffalo Bill Cody's Wild West Show. A national archery champion and World War I veteran, Crazy Bull toured the country giving lectures and demonstrations at churches, schools, and department stores.

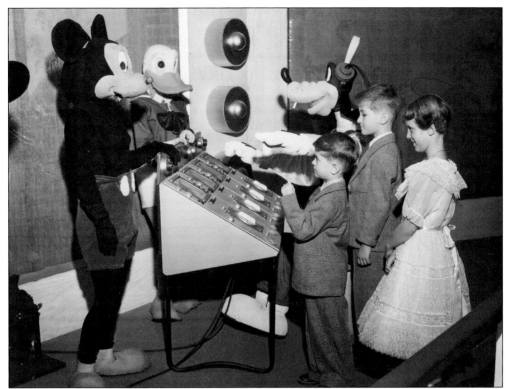

In November 1956, the groundbreaking Anaheim theme park called Disneyland was only a year old, and the television series of the same name was a hit show on ABC. As the holiday season began, Lit Brothers took advantage of Disney-mania to launch its own Disneyland attraction on its fourth floor Toyland, complete with Frontierland, Fantasyland, Tomorrowland, Cinderella's castle, and the Mickey Mouse Clubhouse. In this publicity shot (above), Frank and James Boucher and Susan Crane of the Catholic Charities help Pluto operate a spaceship control panel in Tomorrowland, while Mickey Mouse and Donald Duck watch. In a contrasting photograph from 1958 (below), Greta the guard dog keeps a lonely watch over the Lits bargain basement late at night. (TUL/UA.)

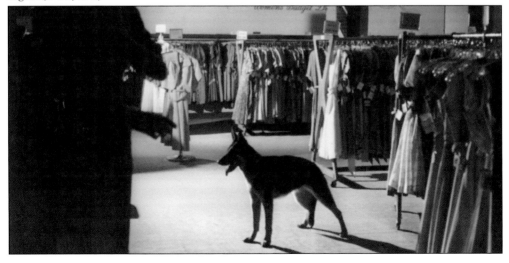

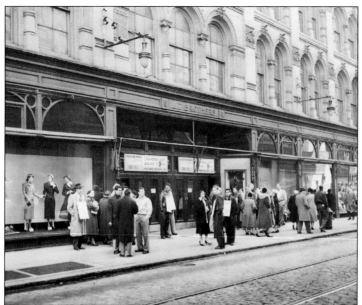

In April 1954, Lit Brothers workers (seen here in front of the Eighth Street entrance) went on strike, demanding better wages and benefits. Strikes would be an ongoing problem for Lit Brothers and other department stores in the postwar years, as employees demanded a greater share of their employers' record profits. In 1973, a criminal warrant was issued against Lit Brothers for using illegal strikebreaking tactics. (PPC/FLOP.)

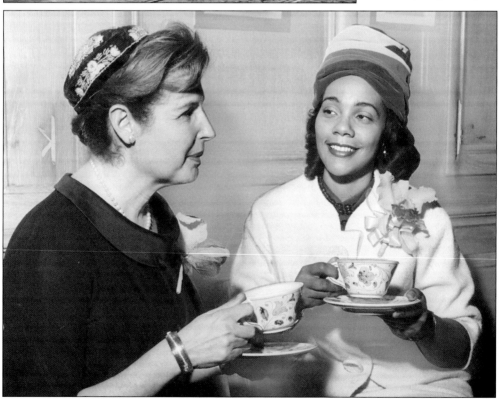

On November 11, 1963, Coretta Scott King (wife of Martin Luther King Jr.) visited Lit Brothers to address members of the Greater Philadelphia Women's Division of the American Jewish Conference on "the American Revolution and the World in Revolution." At a reception afterwards, King, a talented singer, discussed her plans for an upcoming Freedom Concert tour with Mrs. Bernard Polen, president of the organization. (TUL/UA.)

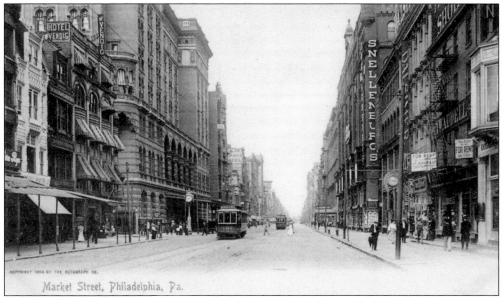

Market Street, Philadelphia, Pa.

Directly across from the Reading Railroad Terminal stood the fortress-like structure of N. Snellenburg & Co., which opened its doors on Market Street in 1889. Known as "the Thrifty Store for Thrifty People," Snellenburg's competed with Lit Brothers for bargain-hunting shoppers. The store site was owned by the Girard Trust, created by 19th-century merchant Stephen Girard to manage his fortune and to establish a school for white male orphans called Girard College. Originally, Girard College was going to be located on this site. But Girard changed his will before he died in 1831, and the school was built at Corinthian and Girard Avenues. Instead, his will directed that the Market Street site "be built upon and improved in such a manner as to secure a safe and permanent income." (Above, Robert Morris Skaler.)

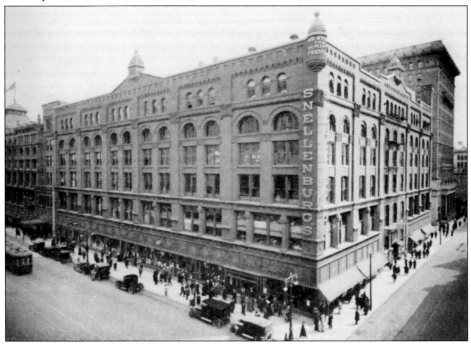

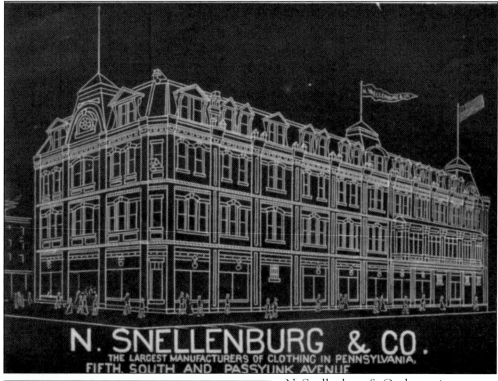

N. SNELLENBURG & CO.
THE LARGEST MANUFACTURERS OF CLOTHING IN PENNSYLVANIA,
FIFTH, SOUTH AND PASSYUNK AVENUE

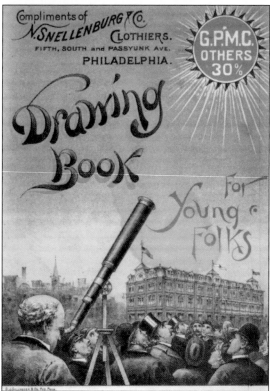

N. Snellenburg & Co. began in 1869 as a small clothing store at 318 South Street, founded by a German immigrant named Nathan Snellenburg. In 1882, he expanded to the building seen above at the intersection of Fifth Street, Passyunk Avenue, and South Street in South Philadelphia. At the time, the store's stated goal was "to sell merchandise at absolutely the lowest prices" but "never to sacrifice quality for cheapness."

This c. 1885 children's giveaway drawing book shows a crowd of customers in front of Snellenburg's South Philadelphia location, tracking the store's ascent in the heavens. Snellenburg's specialty was its men's and boy's clothing, all of which was made either at the store or at its own factory at Broad and Wallace Streets. Snellenburg's boasted that every item of apparel it sold was "Good Philadelphia-made clothing."

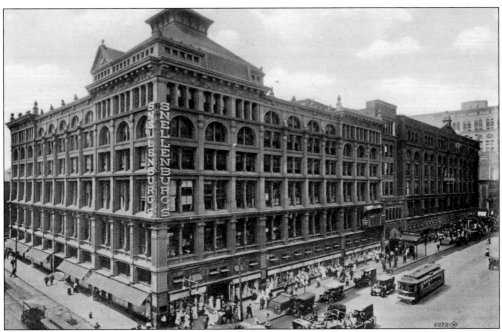

In 1901, Snellenburg's acquired the former headquarters of the insolvent Hood, Foulkrod & Co. at the southwest corner of Market and Eleventh Streets (above). Founded in 1823, Hood, Foulkrod & Co. was one of the many wholesale firms that had dominated Market Street in its pre-department store days. Its replacement by Snellenburg's was a stark illustration of the emergent retail nature of the avenue as the 20th century dawned. Within three decades, the small South Philadelphia clothing shop had become a block-long Market Street department store with branches in New York and Wilmington and 2,500 employees. In 1938, Snellenburg's opened a roof garden for its workers (below), which featured outdoor dancing, table games, and sports facilities (Below, TUL/UA.)

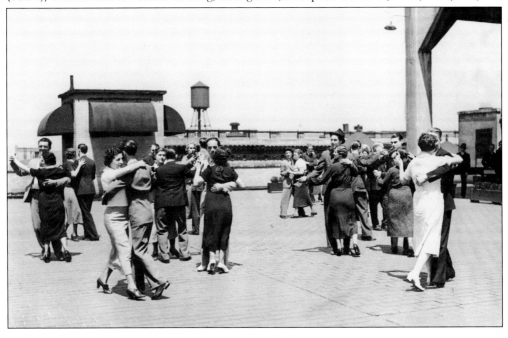

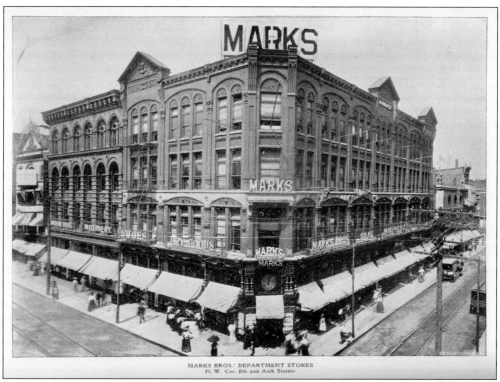

MARKS BROS.' DEPARTMENT STORES
N. W. Cor. 8th and Arch Streets

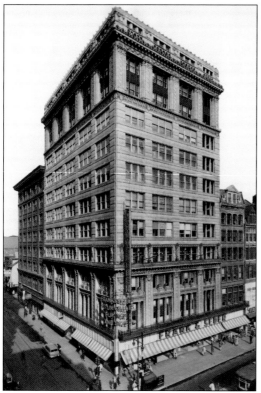

Bucking the Market Street trend, Marks Brothers Department Store opened at the southwest corner of Eighth and Arch Streets in the 1860s. This building was constructed in 1889, after a fire had dislocated the company. Founded as a millinery shop, Marks Brothers remained best known for its women's goods. In 1902, the store closed to reorganize. Although Marks Brothers reopened at 931–933 Market Street in 1904, it was unable to compete with its larger neighbors and closed permanently in 1909. (Robert Morris Skaler.)

Latecomer to Market Street, Frank & Seder was part of a Pittsburgh-based chain that began operations in 1907. Their Philadelphia store opened in 1915 at 1023–1025 Market Street and moved into this skyscraper at the northeast corner of Eleventh and Market Streets in 1925. Despite its motto, "Follow the Leader to Frank & Seder," the store would be the first of the major Market Street department stores to close its doors in 1953. (TUL/UA.)

George Allen, Inc., a women's apparel store that opened at 326 High Street in 1837, moved to 1214 Chestnut Street in 1896. Wishing to expand into a full-fledged department store in the 1920s, Allen's owners were stymied by the high price of Center City real estate. Instead, they decided to build a larger, separate store in bustling Germantown, the "city within the city" in northwest Philadelphia. (GHS.)

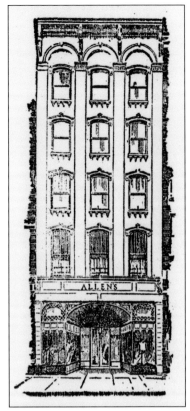

Germantown had developed its own shopping hub around the intersection of Germantown and Chelten Avenues, drawing customers not just from northwest Philadelphia but from nearby Montgomery County. In 1927, George Allen, Inc., opened a flagship store at Chelten Avenue and Greene Street, although it would maintain its Chestnut Street location until 1952. Allen's closed in 1979, a victim of changing demographics and the decline of the Germantown shopping district. (GHS.)

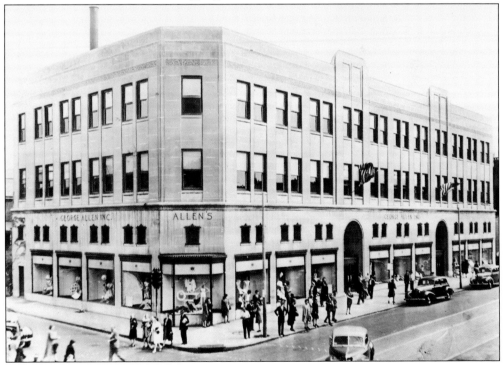

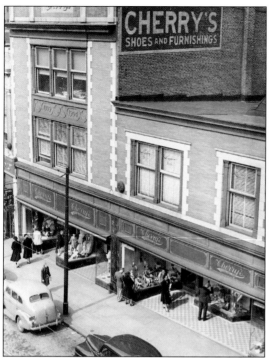

Established in 1809 as a cobbler's shop, Robert Cherry's Sons may have been the longest-lived retail establishment in Germantown. By the time this photograph was taken around 1940, Cherry's had become a full department store, occupying four storefronts at 5541–5547 Germantown Avenue. Cherry's remained best known for its shoes, and many former Germantown residents still recall looking at the bones of their feet in the store's foot x-ray machine. (GHS.)

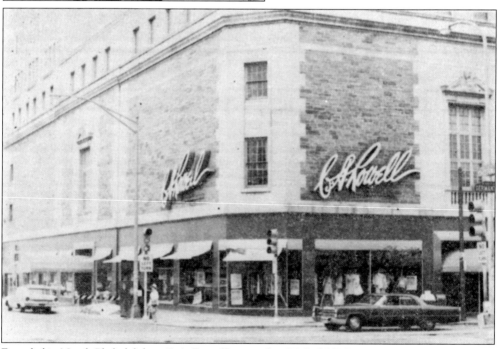

Founded in North Philadelphia, C.A. Rowell's moved to 5615–5617 Germantown Avenue in 1919. In 1940, it relocated to the northwest corner of Germantown and Chelten Avenues, moving to the former Germantown Trust Company building on the southeast corner in 1950. Architect Herbert Beidler designed a neo-Georgian facade for the new location that fit in with contemporary plans to give historic Germantown a Colonial Revival face-lift. Rowell's closed in the 1980s.

Six

CATERING TO THE CARRIAGE TRADE

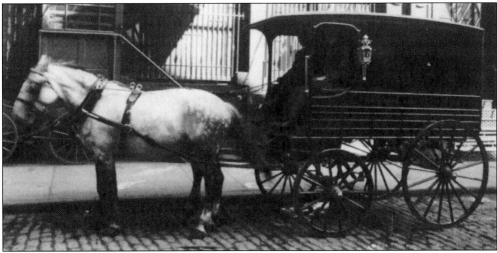

While members of Philadelphia's middle class typically shopped at the large department stores on Market Street, the city's upper crust frequented the more intimate, exclusive shops on Chestnut Street, one block south. Traditionally, elite customers in the 18th and 19th centuries would often arrive at Chestnut Street boutiques in their private carriages, giving rise to the term "carriage trade." Once purchases were made, all but the smallest parcels would be dropped off at the customer's home by horse-drawn wagon. Here, Ruby is seen delivering packages to customers of J.E. Caldwell & Co. Jewelers in this 1904 photograph.

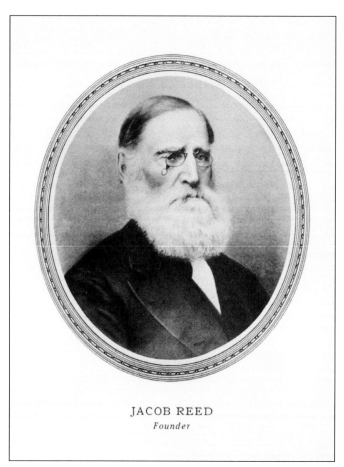

JACOB REED
Founder

Not every shop on Chestnut Street started life as a "carriage trade" store. Such was the case with Jacob Reed, the industrious young tailor who hung out his first shingle in 1824 at 246 High Street. Born in 1803, Reed spent much of his youth as a bonded apprentice in the section of the city then known as the East End.

From 1824 to 1858, Jacob Reed grew to become a full-scale manufacturer of men's clothing for wholesale as well as retail purchase. This photograph shows Reed's East End Clothing House at Second and Spruce Streets, where he offered military uniforms as well as fine clothing. The store's 100th anniversary booklet of 1924 points out the large "one price" signs painted on the building, claiming that Reed was one of the first retail merchants, if not the first, to inaugurate the one-price policy.

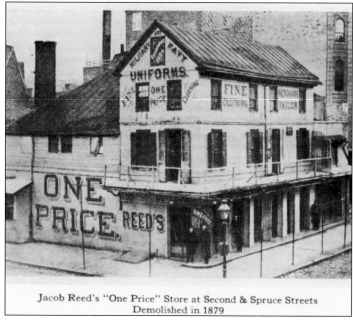

Jacob Reed's "One Price" Store at Second & Spruce Streets
Demolished in 1879

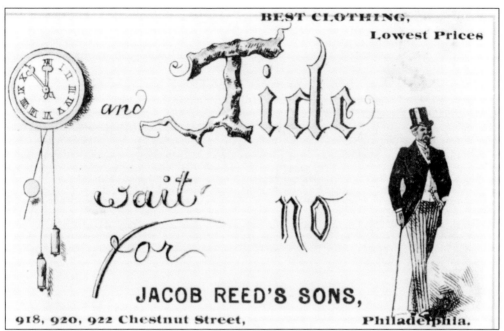

BEST CLOTHING, Lowest Prices and Tide wait for no JACOB REED'S SONS, 918, 920, 922 Chestnut Street, Philadelphia.

In 1877, Jacob Reed retired and handed the reins of his business over to his three sons, who renamed the firm Jacob Reed's Sons. In 1883, the company opened its first store on Chestnut Street at 920 and 922. In the 1870s and 1880s, colorful chromolithographic trade cards like this one were an essential advertising tool for many merchants. Most cards found their way into scrapbooks, a popular pastime of the period.

As mentioned previously, the trend in retailing in Philadelphia was always westward, as residential areas such as Rittenhouse Square began to develop during the last quarter of the 19th century. Jacob Reed's Sons was among the first of the fashionable retail stores to move beyond the boundary of Broad Street. This c. 1900 image shows the first Jacob Reed's store west of Broad Street at 1412–1414 Chestnut Street.

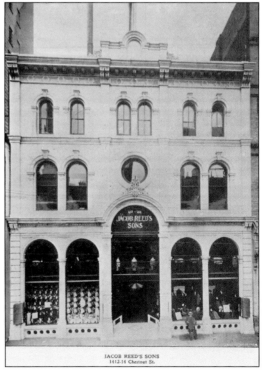

JACOB REED'S SONS
1412-14 Chestnut St.

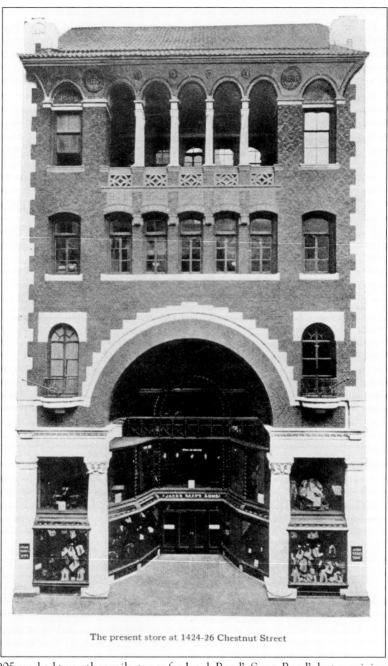

The present store at 1424-26 Chestnut Street

The year 1905 marked two other milestones for Jacob Reed's Sons. Reed's last surviving son Alan incorporated the firm to ensure that the family's legacy would continue. He also commissioned Philadelphia architect William Price to design a new flagship. Located at 1424–1426 Chestnut Street, the building was designed in Price's characteristically eclectic style. The store was decorated inside and out with tiles from Henry Mercer's Moravian Pottery and Tile Works in Doylestown, and it was one of the first buildings in Philadelphia to use reinforced concrete. Jacob Reed's Sons survived until 1983, when it closed it doors. The first floor and mezzanine of the store were then leased by Barnes & Noble bookstore until 1995, when a CVS drugstore took its place.

In 1846, Joseph T. Bailey and Andrew B. Kitchen dissolved the partnership in their lucrative jewelry and silver business. Bailey then joined with his brother Eli and two new partners to form Bailey & Co. In 1859, the firm moved from its original location (see page 13) to a lavish new building at 819 Chestnut Street, across from the Continental Hotel and rival jeweler J.E. Caldwell.

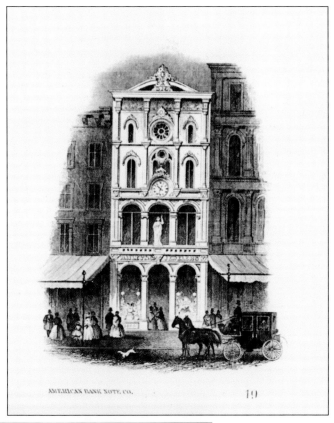

Like J. E. Caldwell's and Jacob Reed's, Bailey's followed the trend westward. After 10 years at 819 Chestnut Street, Bailey & Co. moved to the southeast corner of Twelfth and Chestnut Streets. This image shows the store in 1878 shortly after J.T. Bailey II took on George Banks and Samuel Biddle as partners and just before the firm's third move to 1218 Chestnut Street.

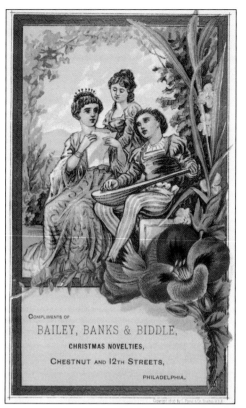

This chromolithographic trade card published by the Louis Prang Co. of Boston advertises Christmas novelties available at Bailey, Banks & Biddle in 1878. Louis Prang, often known as the father of the American Christmas card, produced many of the trade cards distributed by Bailey, Banks & Biddle as well as John Wanamaker and other stores.

This image shows a rare glimpse into the interior of the former Bailey, Banks & Biddle store at Twelfth and Chestnut Streets after it had been taken over by Acker's Quality Store in 1879. Acker's did not renovate the store but used the existing ornate interior as a setting for its specialty and gourmet foods business. Proud of its new home, Acker's issued at least eight postcards of its store at Twelfth and Chestnut Streets.

General Motors Trucks

—and Business Prestige

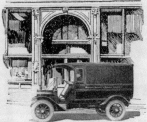

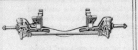

THE GMC FRONT AXLE

Great tensile strength with light weight are combined in GMC Front Axles. Special analysis steel, heat-treated, is employed, with steering knuckles and knuckle arms drop-forged and heat-treated.

IT would be hard indeed to find a better example of the sort of prestige coveted by all high-class retail business than that of The Bailey, Banks & Biddle Company, the famous jewelers of Philadelphia.

Founded in 1832, this house is a Philadelphia institution. Through more than four score years it has been accorded the patronage of the fine old aristocratic families of America's first capital.

Nearly 100 years years ago The Bailey, Banks & Biddle Company sold its precious wares of jewels and plate in a quaint colonial shop and delivered them in a horse-drawn coach.

Today the company occupies a magnificent modern store, containing so extensive a collection of precious stones, jewelry, and objets d'art that it is one of the showplaces of Philadelphia.

And today The Bailey, Banks & Biddle Company is using for its delivery service five GMC Trucks, finished and appointed in a style appropriate to their occupation.

The Bailey, Banks & Biddle Company bought the first three in 1915, and in the following year purchased two more, making a fleet of five which has now been in service from three to four years.

GMC Trucks are for high-class concerns that want their delivery equipment properly to represent them in appearance and performance. GMC reliability has become proverbial—GMC construction is the reason.

The General Motors Corporation gives to GMC Trucks a financial backing that assures permanent availability of service and parts.

GENERAL MOTORS TRUCK COMPANY

One of the Units of the General Motors Corporation

PONTIAC, MICHIGAN, U. S. A.

Branches and Distributors in Principal Cities (530)

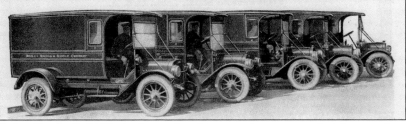

By 1910, Bailey, Banks & Biddle had completed its new showroom and eight-story jewelry and silver manufactory at 1218-20-22 Chestnut Street. Manufacturing was an important part of the store's business. For nearly a century the company would produce the Congressional Medal of Honor, the first 40,000 Purple Hearts awarded, and the class rings for West Point and the US Naval Academy at Annapolis. In this 1919 advertisement, Bailey, Banks & Biddle lent its prestige as America's oldest fine jeweler to the relatively young General Motors Company, founded in 1908. The advertisement extolled the virtues of the store's modern showroom and quality product before stating that "GMC Trucks are for high-class concerns that want their delivery equipment properly to represent them in appearance and performance." Clearly GMC hoped to obtain the same cachet with automobiles that Bailey, Banks & Biddle had with luxury goods.

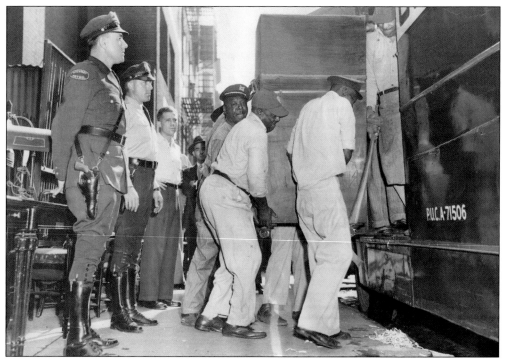

Bailey, Banks & Biddle remained at 1218-20-22 Chestnut Street until September 1953, when it moved its Center City flagship to the southeast corner of Sixteenth and Chestnut Streets, along with three safes full of jewelry, transported under armed guard. The safe shown here contained gems and jewelry valued at over $1 million. (TUL/UA.)

On September 21, 1953, Bailey, Banks & Biddle opened its modern new store at 1530 Chestnut Street with a grand party, but the scent of change was already in the air. In 1961, Bailey, Banks & Biddle sold its assets to the Zale Jewelry Company, Inc. By the early 21st century, Bailey, Banks & Biddle Fine Jewelers could be found in malls across the nation. But in 2002, Zale's shuttered the Center City store, ending the company's 170-year legacy in Philadelphia.

"The Subscriber respectfully makes known to all friends and the public, that he has taken a store at No. 163 Chestnut Street." This announcement by watchmaker James E. Caldwell (right) appeared in the *US Gazette* in June 1839. Born in 1805 in Poughkeepsie, New York, Caldwell came to Philadelphia around 1835. By 1849, he had established himself as one of the city's preeminent retailers of watches, jewelry, and other luxury goods. Shown below is a close-up of Caldwell's second store at 140 Chestnut Street, one block east of the State House, where he had moved around 1844. But by 1858, the location was beginning to decline, as shown by the proliferation of signs on the building here versus the view on page 12. Caldwell moved his business one half mile west to 820 Chestnut Street.

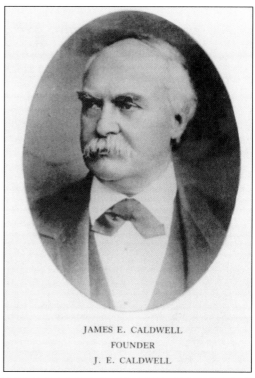

JAMES E. CALDWELL
FOUNDER
J. E. CALDWELL

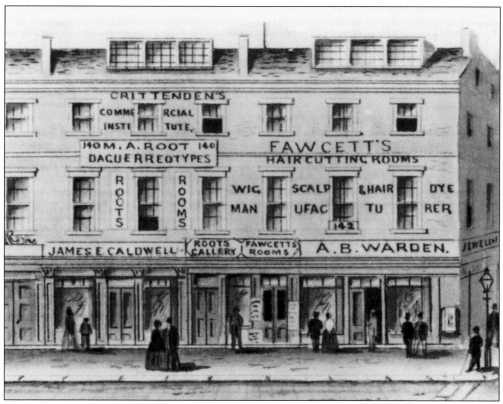

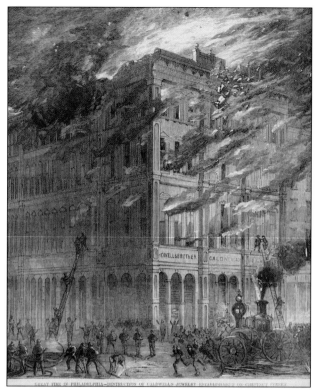

GREAT FIRE IN PHILADELPHIA—DESTRUCTION OF CALDWELLS JEWELRY ESTABLISHMENT ON CHESTNUT STREET

In 1868, Caldwell moved his booming business again to a larger, even more elegant location in the new Burd Building at 902 Chestnut Street. Unfortunately, in the early morning hours of January 14, 1869, the store was rocked by a massive explosion when burglars tried to blow up the safes. The event even made the front page of *Harper's Weekly*. Two night watchmen were killed in the ensuing blaze and the reported losses were over $1 million. But the safes proved impregnable, and $125,000 in gems and watches as well as $400,000 in customer bonds, notes, and deeds was saved. (It was then customary for many people to use jewelers' safes and vaults instead of safe deposit boxes at banks.) The photograph below is a rare view of the store's restored interior as it appeared around 1870.

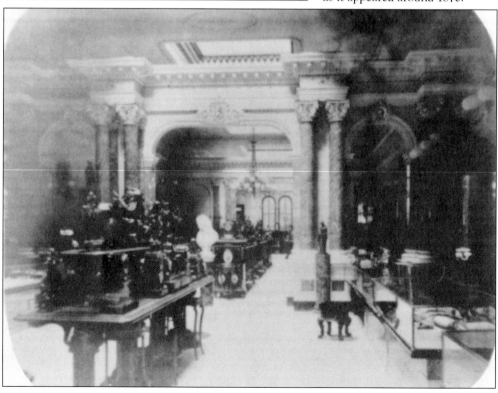

During the summer of 1876, J.E. Caldwell & Co. brought a touch of Chestnut Street elegance to the Centennial Exhibition in Fairmount Park. In the middle of the Main Building of the fair, Caldwell's shared a fine Moorish pavilion with the best silversmiths and jewelers in America, including Tiffany & Co. and Starr & Marcus of New York and the Gorham Co. of Providence, Rhode Island.

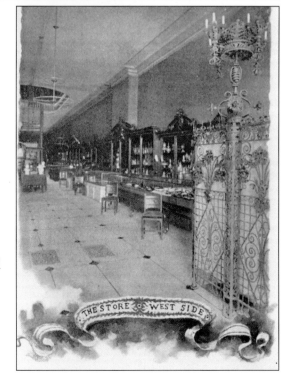

In 1890, to highlight its fine collections of gems and jewelry, watches, clocks, silverwares, bronzes, marbles, and art, J.E. Caldwell & Co. published an unusual illustrated booklet called "The Sultan of Cathay." In it, the genie of the lamp transports the now sultan Aladdin and his grand vizier to a magical place full of wonders called J.E. Caldwell & Co. Here are the wonders the sultan saw when he stepped across its marble threshold.

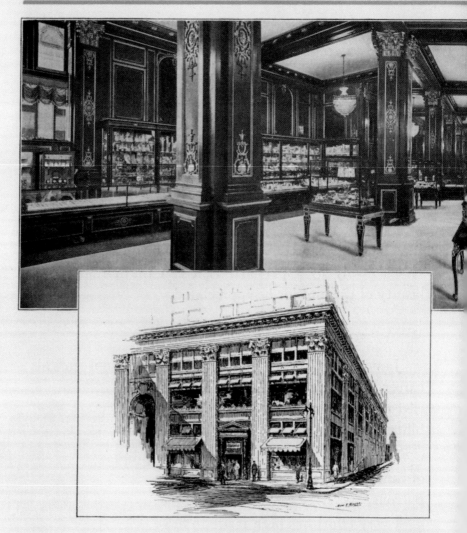

THE J. E. CALDWELL & CO. store of the present day is conveniently located at Chestnut and Juniper Streets, on the site of the old Philadelphia Mint. A total of 27,343 square feet is utilized for the main store and the various departments, which include a modern storage vault for the use of patrons.

In 1916, J.E. Caldwell & Co. leased its last and most magnificent space on the northwest corner of Chestnut and Juniper Streets in the new Widener Building. The Wideners hired their trusted architect, Horace Trumbauer, to design and outfit the new space at the then astronomical cost of $1 million. The main floor covered over 12,000 square feet, making Caldwell's one of the largest jewelry stores in the world, if not the largest. Caldwell's was also the epicenter of Philadelphia social

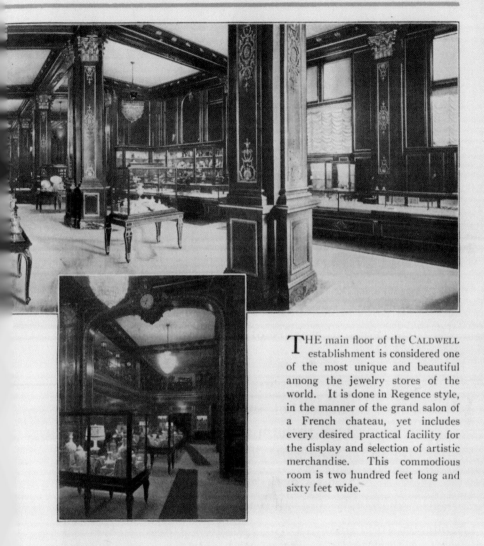

THE main floor of the CALDWELL establishment is considered one of the most unique and beautiful among the jewelry stores of the world. It is done in Regence style, in the manner of the grand salon of a French chateau, yet includes every desired practical facility for the display and selection of artistic merchandise. This commodious room is two hundred feet long and sixty feet wide.

J. E. Caldwell & Company
Philadelphia

life as the official keeper of *The Book*. Maintained by Stationery Department employee George W. Rehfuss, *The Book* was the official listing of all Philadelphia's debutantes and their coming-out dates. It was also the main calendar of elite events like the Assemblies, Charity Ball, First City Troop Gala, and many other social functions inaugurated before the Revolutionary War.

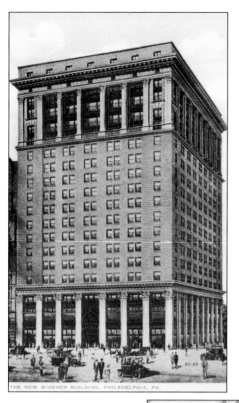

Completed in 1914, the Widener Building was built on the site of the 1833 Second US Mint and later the Mint Arcade building. The 18-story limestone office tower featured a dramatic three-story arcade connecting Chestnut Street to South Penn Square as well as a famous Kugler's Restaurant in the basement. Architect Horace Trumbauer is perhaps best known for his work on the Philadelphia Museum of Art and the Free Library and Family Court buildings on Logan Circle. But he also designed palatial residences for the Widener, Elkins, and Stotesbury families.

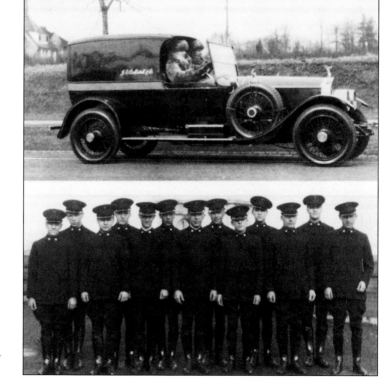

Just a few years before the move to the Widener Building, delivery horses, such as Ruby (seen on page 63), were put out to pasture and replaced in true Caldwell style by a fleet of maroon Rolls-Royces driven by liveried chauffeurs.

In an effort to make its aging flagship look contemporary, Caldwell's began the brutal modernization of its exterior in 1959. The Widener Building completed the desecration in 1963 by filling in the arcade and swathing the lower floors of its Chestnut Street facade in marble slabs. Fortunately, the facade and arcade were restored to their former glory in the late 1980s.

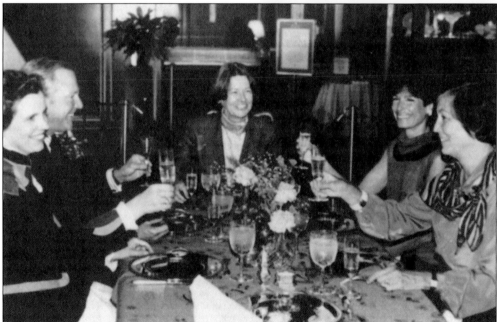

In 1968, control of J.E. Caldwell & Co. left Caldwell family hands for the first time when the company was sold to the Dayton-Hudson Corporation. In 1981, Caldwell's was purchased by a Canadian jewelry company, Henry Birks & Sons. Under the leadership of Birks Caldwell Division president Linde Meyer, the store hosted many social events. Among them was a 1984 luncheon in conjunction with the Philadelphia Craft Show, with, from left to right, Mrs. I. Wistar Morris III, Robert Montgomery Scott, Linde Meyer, Eileen Rosenau, and Mrs. M. Wright Tilghman.

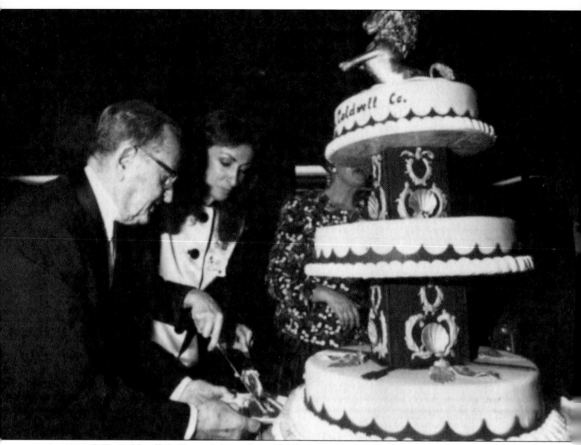

In 1989, J. E. Caldwell & Co. celebrated its 150th anniversary. Seen here are longtime employee Frank Schlichter (hired in 1914) and Mrs. Jonathan Birks as they cut the cake at the employee anniversary party. Unfortunately, Birks' fortunes soon turned sour. It sold Caldwell's, along with other luxury jewelry chains it had acquired during the 1980s, including Peacock's in Chicago and Shreve Crump & Low in Boston. After local efforts to purchase Caldwell's failed, the chain was sold to a Southern jewelry company in 1992. The new company tried to understand the Philadelphia market and revitalize the Caldwell brand but was unable to make the flagship store profitable again. By the summer of 2003, Chestnut Street was without a J.E. Caldwell & Co. for the first time in 164 years.

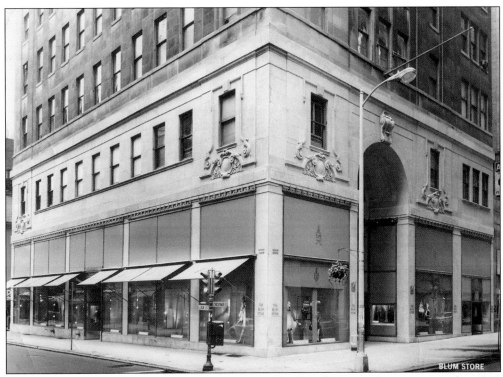

At the beginning of the Roaring Twenties, J.E. Caldwell and Wanamaker were joined at 1300 Chestnut Street by the Blum Store. Founded as Blum Brothers Dry Goods in the late 19th century and originally located at Tenth and Market Streets, the Blum name was purchased by Maurice and Annie Kass Spector in 1920. The Spectors, seasoned merchants who had owned their own department store in New Freedom, Pennsylvania, felt that trading under an established Philadelphia name would be better for business. Thus, Blum Brothers became the Blum Store and moved to a new building on the former site of Philadelphia's branch of Bonwit Teller.

As the Blum Store, the company specialized in the finest ladies' designer fashions and accessories as well as children's clothing. Here is a rare view of the store's elegant first-floor interior around 1935. (Michael Ciliberti.)

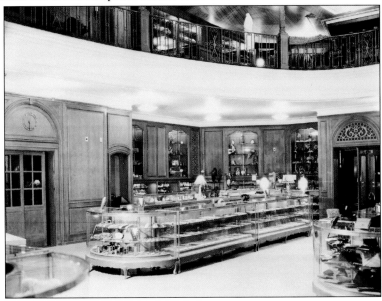

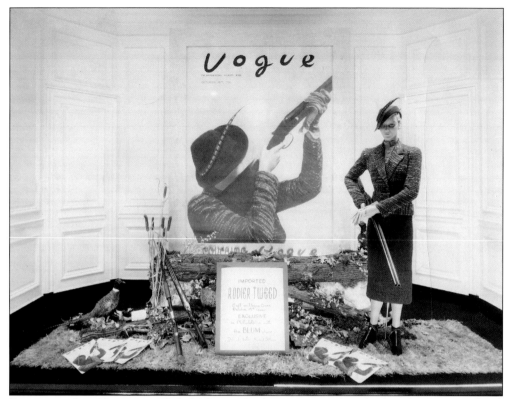

During retail's golden age in Philadelphia and other cities, window displays (or show windows) played an essential role in the shopping experience. The Blum Store consistently held its own in display competitions against Wanamaker's across Chestnut Street. This November 1936 show window, inspired by the latest issue of *Vogue* Magazine, enticed sports-minded ladies to indulge in the latest designer tweeds by Rodier, available exclusively at Blum's. (Michael Ciliberti.)

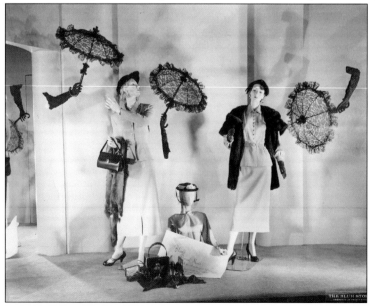

The logo for the Blum Store was an elegant drawing of a gloved hand holding a lace parasol, and it was used to full advantage in this rather expressionistic window display from the 1940s. The window introduced "Parasol Mauve—A New Color in Your Life!" (Michael Ciliberti.)

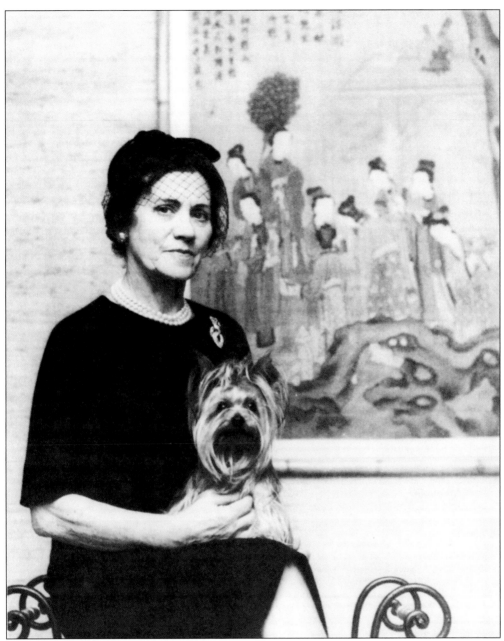

Not long after it opened, the Blum Store hired a young woman by the name of Nan Duskin as a coat buyer. Duskin had previously worked at Bonwit Teller, where by the age of 21 she had become the store's youngest casual coat and suit buyer. In 1926, backed by Philadelphia socialite and former customer, Rebecca Thompson, Duskin opened her own ladies' shop just north of Rittenhouse Square at the southwest corner of Eighteenth and Sansom Streets. By 1936, Nan Duskin had moved into an elegant brownstone at 1729 Walnut Street, where she would reign as Philadelphia society's fashion czarina for over 22 years. In 1959, Duskin's leadership in the fashion industry was recognized when she became the only woman ever to be inducted into Boston University's Business Hall of Fame. (TUL/UA.)

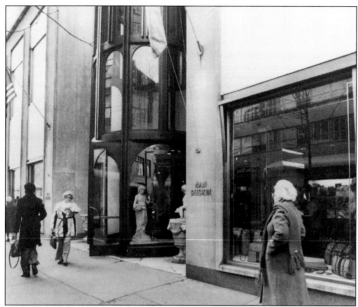

Suffering from ill health, Nan Duskin sold her store to philanthropist H. Richard Dietrich in 1959 for $1 million, a move she regretted until her death in 1980. Once Dietrich had purchased the store, he hired architect John MacFayden (who would later design the Mann Music Center) to give the expanded store a sleek new facade. Its unique cylindrical bronze entrance soon made the store a Walnut Street landmark.

Nan Duskin's interior was also updated to appeal to a new generation of shopper who wanted to browse through prêt-à-porter designer fashions, rather than sit while live models displayed couture ensembles one at a time, as had been the custom. High-end giftware selections were also added. Nan Duskin maintained its cachet among Philadelphia's stylish women through many management and ownership changes but finally closed its doors in early 1995. (TUL/UA.)

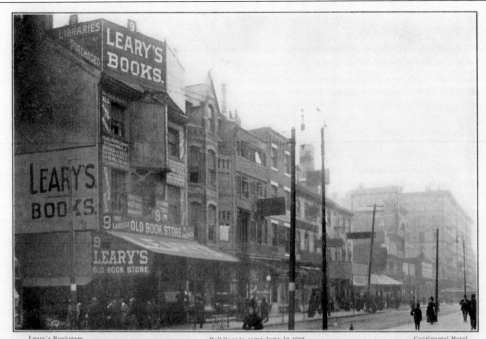

No volume about Philadelphia retailers would be complete without Leary's Book Store. Considered the oldest bookstore in America, Leary's was founded in 1836 by Maryland native William A Leary. Initially Leary bought, sold, and even published books. Edwin S. Stuart, the store's manager under William Leary Jr. took over the business in 1876 and moved the store from Fifth and Walnut Streets to Ninth and Ludlow Streets a year later.

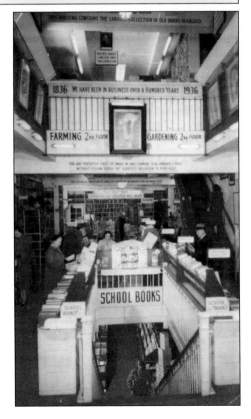

Eventually Edwin Stuart turned the business over to his brother William and entered politics, first becoming mayor of Philadelphia and then governor of Pennsylvania. William replaced Leary's old building with a new seven-story facility. This postcard shows the interior of Leary's sometime after its 100th anniversary in 1936. The store was always busy and advertised itself as having the largest collection of old books in America. (Robert Morris Skaler.)

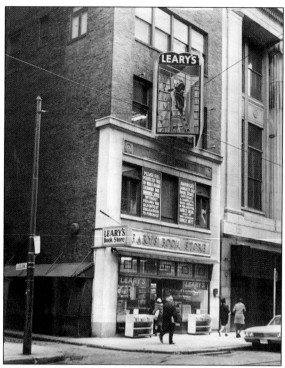

Leary's trademark was a variation of a mid-19th-century painting by German artist Carl Spitzweg affectionately called *The Old Bookworm*. The iconic image graced the outside of the building, as can be seen (left) during the store's final days. In 1968, the Leary's building was sold to Gimbels, which had surrounded it on three sides since the 1920s and had been trying to acquire the property for years.

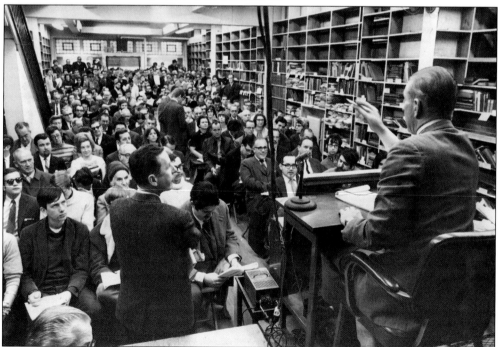

Leary's president W. Stuart Emmons, grandson of William Stuart, attempted to interest a buyer for the business but the outmoded stock, added to the difficulties of moving, made that impractical. In January 1969, the remaining stock was auctioned by John M. Freeman of Freeman's Auction House. (TUL/UA.)

Seven

CELEBRATING THE HOLIDAYS

In the 19th century, Easter was more of a shopping and gift-giving event than was Christmas, at least for adults. Every fashionable Philadelphian showed off their new spring finery at the Easter Parade on Rittenhouse Square. Since entertaining was frowned upon during Lent, Easter also kicked off the spring/summer social season. J.E. Caldwell & Co. marked Easter by distributing this beautiful chromolithograph printed by the Marcus Ward Co. of Belfast and London. One of a series of four cards showing spring flowers, the chromo reminded Caldwell's customers to celebrate Easter by purchasing an exquisite piece of jewelry or an objet d'art.

By the mid-20th century, Easter was still an opportunity to buy new clothes, but the gift-giving now focused on children. Retailers "Easter-ized" their Christmas displays, substituting the Easter Rabbit for Santa Claus. In 1950, a toddler named Terry Anne stared apprehensively at a giant bunny in Uncle Wip's Toyland at Gimbels, who was doubtless asking her what she wanted in her Easter basket.

"Just hand over the chocolate, and no one gets hurt," seems to be what the second girl from the left is thinking in this 1963 Lit Brothers scene. Lits took its Enchanted Colonial Christmas Village, filled it with rabbits and lambs, and renamed it the Enchanted Colonial Easter Village. The five children contemplating the bunnies are, from left to right, Ann Tisdale, Pattie Tisdale, Joyce Bokunewicz, Maureen Christman, and Eileen Christman. (TUL/UA.)

During the 1880s, John Wanamaker purchased two religious paintings by a then fashionable Austro-Hungarian artist named Mihály Munkácsy: *Christ before Pilate* (painted 1881) and *Golgotha* or *The Crucifixion* (seen above, painted 1884). For *Christ before Pilate* alone, Wanamaker paid $110,000 in 1887, the equivalent of $2.6 million today. After hanging in the Wanamaker home for years, the two paintings were displayed at Wanamaker's store during the Easter season until a new corporate owner sold them in 1980. Today, both works belong to the Déri Museum in Debrecen, Hungary. Not all of Wanamaker's Easter decorations were so lugubrious (below). In 1960, the Grand Court was filled with artificial cherry blossoms, while birds fluttered in a giant birdcage hung from overhead. (Above, James Hill Jr.; below, PPC/FLOP.)

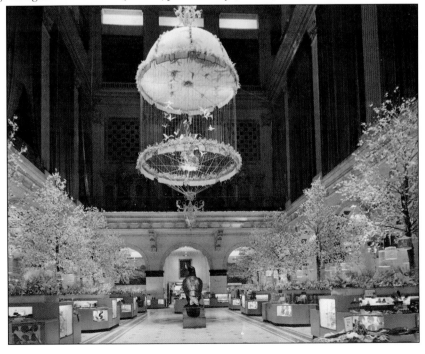

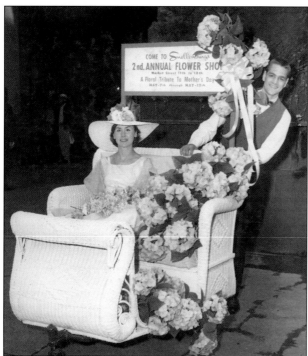

After Easter and Christmas, other holidays were celebrated on a smaller, more modest scale. In this photograph (undated but probably from the 1950s), two Snellenburg's employees mark the store's tribute to Mother's Day, its second annual flower show. The wicker pushcart is similar to those that have been a popular mainstay on the Atlantic City Boardwalk for over a century. (PPC/FLOP.)

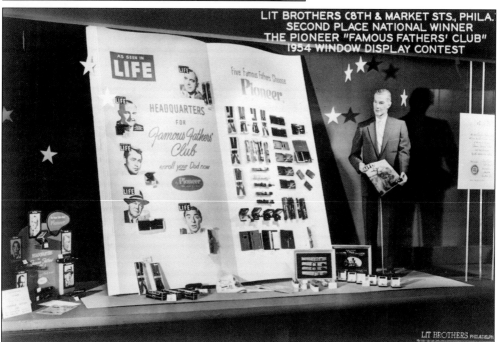

To commemorate Father's Day in 1954, Lit Brothers created a merchandising tie-in with Pioneer, a maker of men's belts, wallets, and furnishings. Children could enroll their fathers in the Pioneer Famous Fathers' Club, where they could join such distinguished colleagues as bandleader Paul Whiteman, commentator Grantland Rice, and actors Eddie Cantor, Alan Ladd, and Pat O'Brien. The window won second prize in the Pioneer window display contest. (TUL/UA.)

On November 25, 1920, Thanksgiving Day, 50 Gimbel Brothers employees staged a ragtag parade of 15 decorated cars, culminating with a fireman dressed as Santa. This was the world's first Thanksgiving Day Parade, concocted by Ellis Gimbel to promote the store's Christmas business by making kids think that the *real* Santa Claus lived at Gimbels. Although the parade attracted little attention at first, it soon became a beloved Philadelphia tradition that endures today. Four years after Ellis Gimbel's brainstorm, a New York department store named Macy's stole his idea. Here, two clowns in the 1953 Thanksgiving Day Parade promote Gimbels' Toyland.

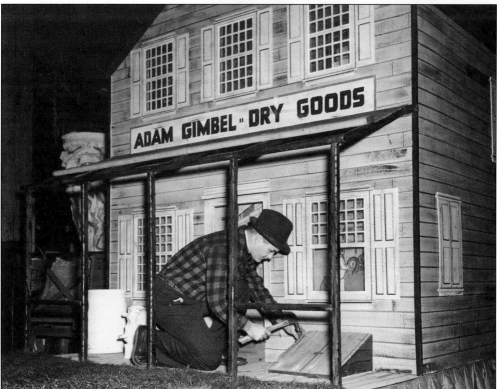

Over the years, "Uncle Wip's Thanksgiving Day Parade" (as it was originally called in honor of the host of Gimbels' popular children's radio show) grew larger, longer, and more elaborate. In preparation for the 1941 parade, a workman constructs a model of Adam Gimbel's original dry goods store in Vincennes, Indiana. (TUL/UA.)

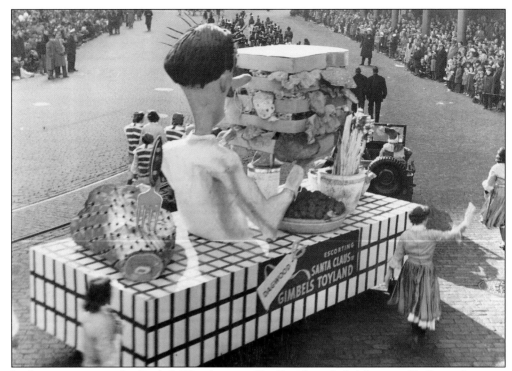

In the postwar years, the Gimbels Thanksgiving Day Parade included floats and balloons featuring popular cartoon characters from newspapers, radio, and eventually television. In 1949, Dagwood, Blondie's omnivorous comic strip husband, hoisted a sandwich larger than his head, with a glazed ham on standby in the background (above). His float is approaching the Arcade Building on the right, later demolished for Dilworth Plaza. In 1950, a giant Howdy Doody burst out of an oversized television screen (below) to the delight of the Peanut Gallery on the float and the live children in front of Philadelphia City Hall. (TUL/UA.)

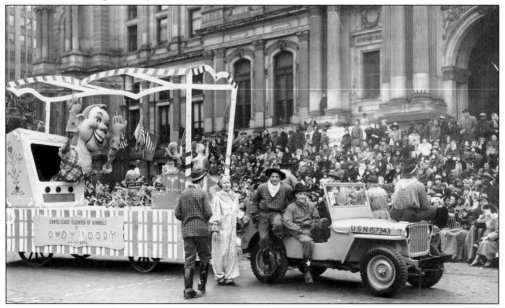

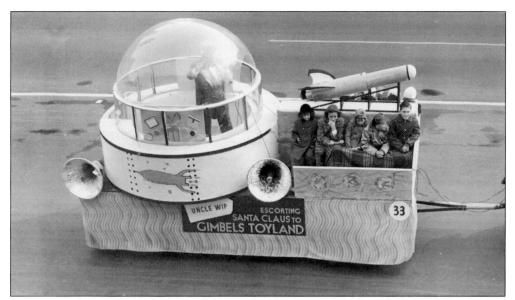

In 1952, Uncle Wip looked ready to thwart a Russian invasion in his bubble-topped spaceship, complete with missile. At this time, the parade began at Montgomery Avenue and Broad Street and proceeded south on Broad to Philadelphia City Hall. The 1954 parade consisted of 40 floats and 5,000 marchers, and it was watched by half a million live spectators and millions of television viewers. (TUL/UA.)

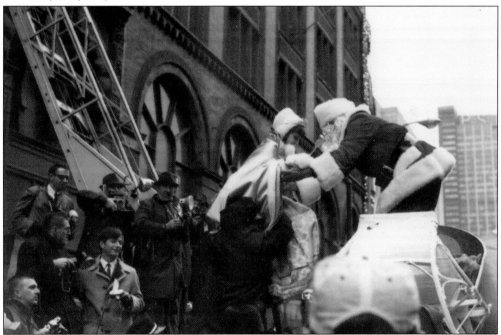

Every parade ended with Santa Claus (usually played by a Philadelphia fireman) clambering up a fire truck ladder to a window on an upper floor of Gimbels, where he would reside until Christmas Eve. When Gimbels closed in 1986, the parade was adopted by other sponsors. Today, the 6abc/ Dunkin' Donuts Thanksgiving Day Parade proceeds up the Benjamin Franklin Parkway to the Museum of Art, where Santa bounds up the stairs à la Rocky. (Philadelphia City Archives.)

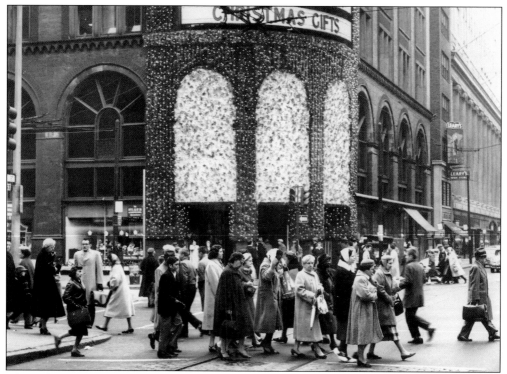

Above, holiday shoppers hurry past the main entrance of Gimbels at Ninth and Market Streets c. 1955. To the right, Leary's famous "Bookworm" sign is visible. Below, a plethora of playthings tempt Depression-era shoppers in a 1930s Gimbels show window. The "Store of a Million Christmas Gifts" had a knack for offering the most unique and innovative toys. At Christmas 1945, Gimbels gambled on a new toy: a flexible metal coil called a "Slinky," developed by a young naval engineer named Richard James. Within 90 minutes, all 400 Slinkys were snapped up at $1 apiece, and a toy empire was born. Thanks to this intuition and experimentation, the national Gimbels chain grossed $286 million in 1953. (Above, TUL/UA; below, PPC/FLOP.)

As Gimbels prospered, it continued to share its good fortune with the less fortunate, maintaining the late Ellis Gimbel's commitment to philanthropy. In this 1958 photograph, orphans at a Catholic Charities Christmas party at the Navy Yard receive a visit from Santa, bearing bags of toys and clothing from Gimbels.

By the 1960s, it was getting harder to impress young baby boomers, especially as other department stores upped the ante with animatronics and monorails. During this time, Gimbels installed a "Winter Wonderland" ice skating rink on its fifth floor, complete with hanging lights and painted scenery. While children were preoccupied with staying on their feet, their parents could shop for those special gifts from "Santa." (TUL/UA.)

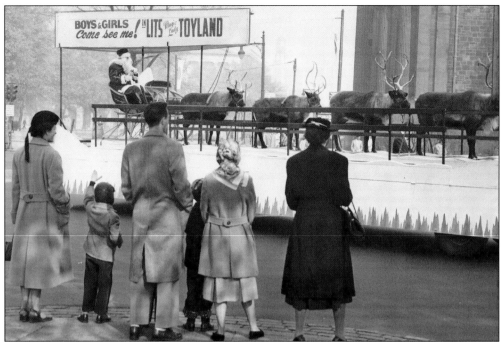

Although Lit Brothers targeted the bargain-minded, it went all out at Christmastime. On November 1, 1952, Lit Brothers even dared to beat Gimbels to the punch by staging its own holiday parade down the Parkway, complete with a Mummers' band, Bozo the Clown, and the Lit Brothers Magic Lady. The climax of the parade was a float bearing Santa Claus with four live reindeer (above). At Lits, Santa (who was advertised as "making his first appearance in the city this year") distributed gifts to waiting children before taking the escalator to the Magic Lady Toyland on the fourth floor. By 1957 (below), Lit Brothers had abandoned the idea of going head-to-head with Gimbels over holiday parades. Instead, it invited children to visit Zorro's Hacienda, offering another tie-in with the hot Disney-sponsored television show of the year. (Both, TUL/UA.)

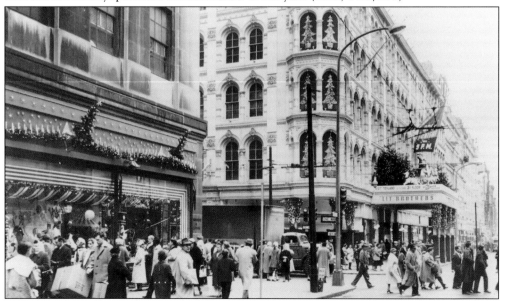

In 1962, Lit Brothers hit the holiday jackpot with the Enchanted Colonial Christmas Village, a walk-through display crafted in Germany. Eighteen vignettes depicted Christmas in 18th-century Philadelphia with animated figures, storefronts, and painted backdrops. In 1966, Susan Schlachter (Miss Christmas), Lit Brothers president J.P. Hansen, and four-year-old Karen Nilson cut the ribbon opening the village before a backdrop of Christ Church, watched by several animatronic carolers. (TUL/UA.)

In the Enchanted Colonial Christmas Village, visitors could walk down a street complete with a blacksmith, general store, baker, and toy maker, watching the inhabitants prepare for Christmas. The Enchanted Village was a holiday fixture until Lit Brothers closed in 1977. After languishing in storage for years, the display is now being refurbished; each Christmas, selected scenes are put on display at the Please Touch Museum in Fairmount Park. (TUL/UA.)

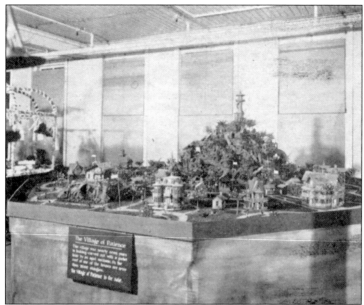

Ready to instill Quaker values in even its younger customers, Strawbridge & Clothier displayed the Village of Patience in its toy department in 1907. The plaque explained that it had taken an aged, very patient mechanic seven years to carve the miniature village, using only a pocketknife. One house alone had more than 18,000 shingles on its roof. The village was for sale, although the price was not specified.

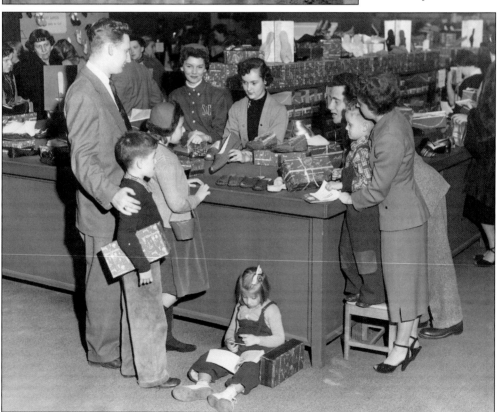

Patience is a virtue that the little girl on the floor could have cultivated as she waits for her father and older siblings to select slippers for the family's mother at the Strawbridge & Clothier ladies' shoe counter. In this photograph from the late 1940s, one of the saleswomen wears a jacket with a distinctive "S&C" monogram. (PPC/FLOP.)

A huge illuminated Christmas wreath decorates Strawbridge & Clothier's main entrance in this 1987 photograph. Another holiday custom at the store was choral music. Longtime president Herbert J. Tily, a talented amateur musician, helped form an employee chorus in 1904. For decades, the Strawbridge & Clothier chorus gave daily concerts at the store during the Christmas and Easter seasons and led a Carol Sing on Christmas Eve morning. (PPC/FLOP.)

On November 11, 1985, Strawbridge & Clothier introduced the Dickens Village, a 26-scene interpretation of Charles Dickens's *A Christmas Carol*. The walk-through attraction covered 6,000 square feet and included hundreds of animated characters in historic settings. A huge success, the village attracted nearly 170,000 visitors in its first six weeks. After Strawbridge & Clothier closed, Macy's acquired the Dickens Village and now presents it as part of its holiday attractions. Here, Ebenezer Scrooge is menaced by the ghosts of those who never learned the true meaning of Christmas. (PPC/FLOP.)

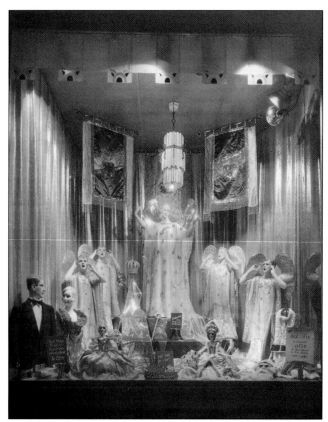

After Strawbridge & Clothier opened its first branch stores at Ardmore and Jenkintown, it brought the same sophistication in window display and store decoration to its suburban outposts that it employed in Center City. This extravagant store window, unveiled at the Jenkintown store shortly after its 1931 opening, utilized silk banners, designer dolls, an elegant young couple, a fashion-forward angel, and a cheerleaders' squad of cherubim to beckon Christmas shoppers. Jenkintown had never seen anything like it. (OYRHS.)

For Christmas 1956, the Jenkintown store decided on a circus caravan display in its toy department, complete with a juggling seal. The store employees assembling the circus wagon are, from left to right, Peter J. Amon, Reginald Cornley, and Jenkintown display manager Fred Huber. At this time, the Strawbridge & Clothier Display Department began to design their Christmas decorations in early spring. (Mr. and Mrs. Francis R. Strawbridge III.)

Among Philadelphia department stores, Wanamaker's was renowned for its elaborate Christmas displays. In 1930, Wanamaker's issued this visitor's guide to its peculiarly Anglophile children's attraction, "No. 10 Joytoy Street, the happiest street in the City of Perhaps." According to the booklet, No. 10 Joytoy Street was "built by the FAIRIES, who left their home at 10 DOWNING STREET when the PRIME MINISTER grew so busy with affairs of State."

This map of the City of Perhaps pictures all of the attractions that lurked behind Believe-It-Gate, including the homes of Wee Willie Winkie, Little Boy Blue, Little Jack Horner, Old King Cole, and Peter Pan. At the center of the city was No. 10 Joytoy Street, where Prime Minister Santa Claus lived. Once children left the City of Perhaps, they passed through Grownup-Gate and returned to the real world.

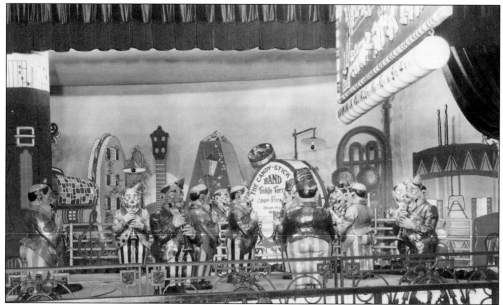

In the boom year of 1926, visitors to Wanamaker's toy department were regaled by this elaborate animated display, "the Candy-Stick Boy Band, featuring Tinkle-Terry on Candy-Sticks." Wanamaker's Christmas decorations were a Philadelphia tradition almost as old as the store itself. In December 1885, John Wanamaker curtained a window displaying "A Visit from St. Nicholas" because the number of rapt spectators was blocking pedestrian traffic on Chestnut Street. (PPC/FLOP.)

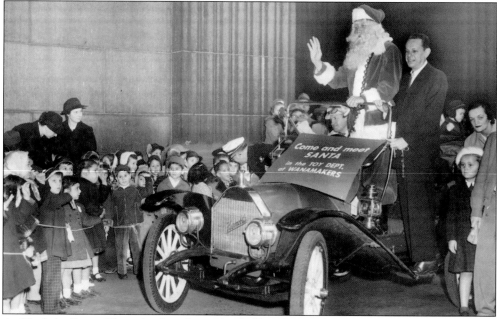

At Gimbels, Santa Claus clambered up a fire ladder. At Lits, he came on a flatbed trailer with live reindeer. But at Wanamaker's, Santa traveled in style. Especially on November 20, 1953, when Old Nick arrived at the store in a chauffeur-driven 1910 Hupmobile. Santa (played by Paul Goldsmith) is accompanied by driver Ted Fiola (in hat and goggles) and Wanamaker's president Richard C. Bond. (PPC/FLOP.)

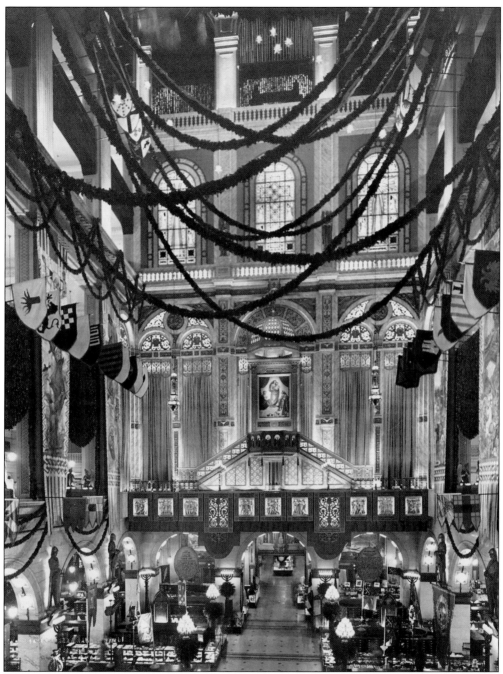

Until the 1970s, Wanamaker's Christmas and Easter displays had a strongly religious orientation, which would be seen as politically incorrect in such a public space today. After John Wanamaker's son Rodman took over the store in 1922, its holiday displays also became more elaborate and artistic. In December 1931, as the Depression deepened, the entire Grand Court was transformed into a cathedral with faux stained-glass windows and inlaid paneling, while garlands, banners, and lanterns hung overhead. The exposed organ case was covered over to provide a framework for the centerpiece, a copy of Raphael's *Sistine Madonna*. (PPC/FLOP.)

In the 1950s, Wanamaker's placed a Christmas Cathedral in the Market Street end of the Grand Court across from the organ case, transforming the court into Cathedral Square. Besides the Nativity scene in the central portal, the display also featured figures of Biblical disciples and prophets and stained-glass windows depicting the Annunciation and the Flight into Egypt. Tableaux from the Nativity were also featured in the rows of Gothic arches along the store's other two walls and under Gothic canopies on the display counters.

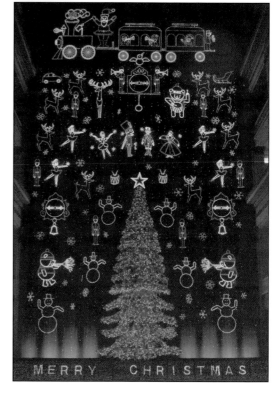

In November 1955, Wanamaker's introduced its best-loved and most durable holiday tradition, the Christmas Light Show. Originally the show consisted of a giant Magic Christmas Tree in changing colors and Enchanted Fountains that danced to music. Over the years, a variety of lighted figures were added, including snowmen, teddy bears, reindeer, and ballerinas, all topped by Santa steering the Holiday Express. The Light Show continues to be a Philadelphia holiday favorite today at Macy's, although a new narration by Julie Andrews has replaced the original one by sportscaster John Facenda. (Bruce Conner.)

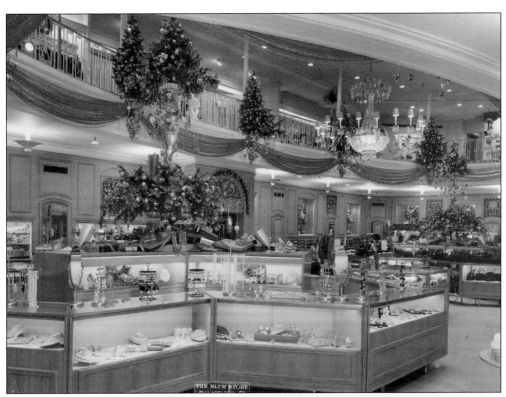

Specialty stores also decked the halls for the Christmas holidays, although their displays were inevitably on a smaller scale than those at large department stores. The Blum Store on Chestnut Street, seen here around 1965, was decorated elaborately during the holiday season. The original color photograph shows the store bedecked not in red and green, but in the store's signature mauve, accented with gold and teal. (Michael Ciliberti.)

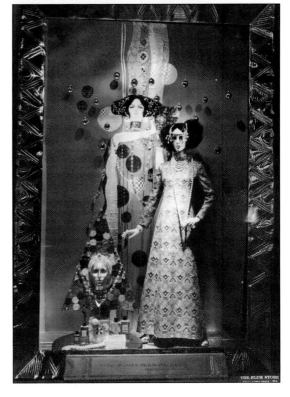

Center City residents used to stroll on Chestnut Street on Friday nights to see the new displays in the boutique windows, in the days when these were changed weekly. A favorite stop was the elaborate windows of the Blum Store, especially during the holiday season. In the mid-1960s, the Blum Store featured haute couture spiced with some hippie sensibilities, influenced by artists like Gustav Klimt. (Michael Ciliberti.)

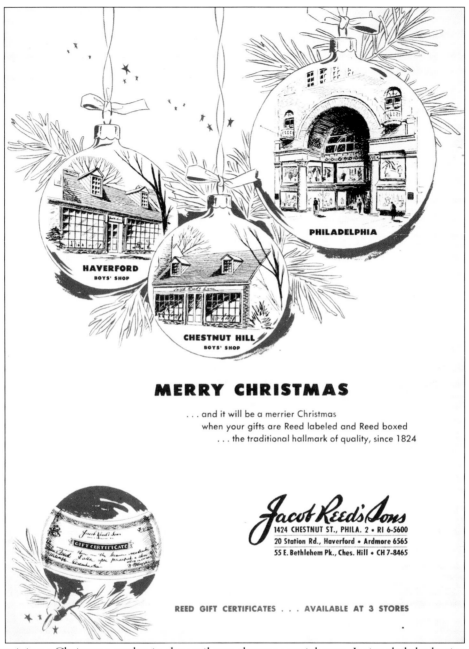

Receiving a Christmas catalog in the mail was always a special treat. It signaled the beginning of the holiday shopping season, whether it came from a big department store or from a specialty shop like Jacob Reed's Sons. Shown here is the rear cover of Reed's festive 1950 Christmas catalog, which suggested, "To men difficult to fit, hard to please or who 'have everything' . . . give a Reed's Gift Certificate." In the mid-1920s, Jacob Reed's had branches in Atlantic City, New Jersey; Annapolis, Maryland; and Washington, DC. But by 1950, only the Chestnut Street flagship and boys' shops in Haverford and Chestnut Hill remained. In 1954, J.E. Caldwell & Co. would take over the Jacob Reed's site in Haverford, when Reed's opened a full-service store on Lancaster Avenue east of Station Road.

Eight

THE AGE OF EXPANSION

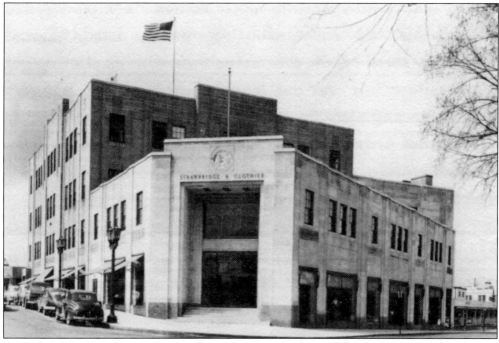

As Philadelphia's population began to move to the suburbs, so did Center City stores, selecting locations near major transportation terminals. In 1930, Strawbridge & Clothier opened its first branch in Ardmore (seen here after a 1950 expansion). Designed by Frederick Dreher, the Ardmore store was part of Suburban Square, the second planned shopping center in America. Before long, the elegant emporium was being called "the Ardmore Club" by its Main Line customers. Although Pittsburgh-based Frank & Seder had opened an Upper Darby branch in October 1929, Strawbridge & Clothier was the first Philadelphia-based department store to open a branch location.

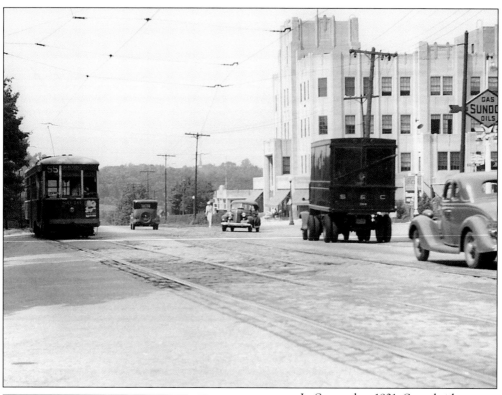

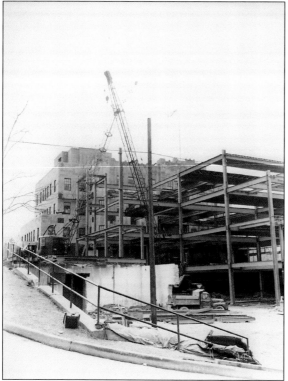

In September 1931, Strawbridge & Clothier opened its second branch on the Old York Road in Jenkintown, north of Philadelphia. Designed, like the Ardmore store, by Frederick Dreher, the Jenkintown store was built on the site of the John Milton Colton estate Wyndhurst, replacing a Horace Trumbauer mansion. Although Jenkintown was still surrounded by open fields, the new store was easily accessible via trolley or train. (OYRHS.)

During 1953–1954, Strawbridge & Clothier expanded the Jenkintown store, nearly doubling its size to over 150,000 square feet. It also installed air-conditioning throughout the store and added an extensive double-decker parking garage. The size of the garage was an indication of the rapid increase in population growth and automotive traffic in Philadelphia's suburbs during the years after World War II. (OYRHS.)

In 1954, Strawbridge & Clothier hosted a square dance for Jenkintown residents on the upper deck of its new garage. Strawbridge & Clothier would occupy its Jenkintown store until 1988, when it relocated to the Willow Grove Mall. Today, the building (renamed Jenkins Court) is in the National Register of Historic Places and is occupied by offices and an Outback restaurant. (OYRHS.)

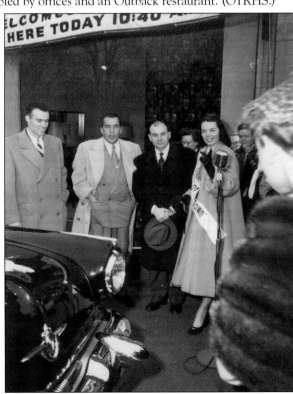

On February 21, 1952, Strawbridge & Clothier Jenkintown experienced a touch of Broadway glamour when Ed Sullivan, host of the television show *Toast of the Town* (later *The Ed Sullivan Show*), visited. After receiving an award for Outstanding American Salesmanship, Sullivan acted as emcee for a combined furniture, fashion, and automobile show. The photograph shows him with one of the 1952 Lincoln automobiles featured in the show. (OYRHS.)

STRAWBRIDGE & CLOTHIER

After opening its third branch in Wilmington in 1952, Strawbridge & Clothier spent $8 million to launch its first mall anchor store at Cherry Hill, New Jersey. The architectural design by Victor Gruen (above) shows the store's interior entrance in what was then the Delaware Valley's first covered mall. When it opened in 1961, Cherry Hill was Strawbridge & Clothier's largest branch at 215,000 square feet and soon became its most profitable store. In 1970, Strawbridge & Clothier opened its eighth branch and second New Jersey store at the abandoned Echelon Airport in Camden County, near the terminus for the new PATCO Lindenwold High Speed line (below). This contemporary postcard shows the interior entrance to the three-story store at Echelon Mall, fronted by an ornamental fountain and trees. (Above, TUL/UA; below, Paul M. Puccio.)

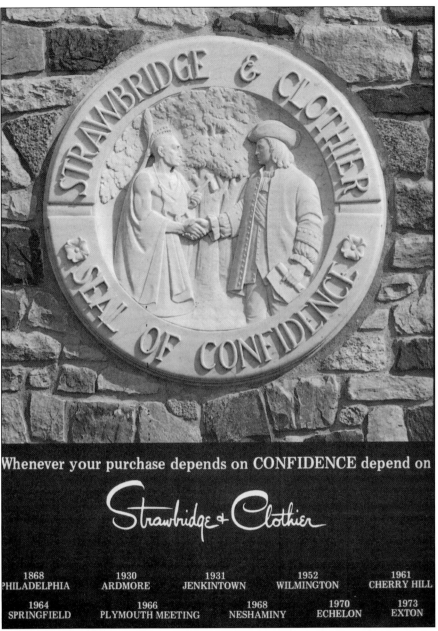

Whenever your purchase depends on CONFIDENCE depend on

Strawbridge & Clothier

1868	1930	1931	1952	1961
PHILADELPHIA	ARDMORE	JENKINTOWN	WILMINGTON	CHERRY HILL

1964	1966	1968	1970	1973
SPRINGFIELD	PLYMOUTH MEETING	NESHAMINY	ECHELON	EXTON

"The future holds no limits to our company's expansion," boasted Strawbridge & Clothier chairman G. Stockton Strawbridge in 1968. When America celebrated its bicentennial seven years later, Strawbridge & Clothier could point with pride to its chain of 10 stores, along with seven Clover discount stores. The Center City flagship was rebounding, thanks in part to G. Stockton Strawbridge's efforts to rehabilitate Market Street East. But Strawbridge & Clothier's rapid growth masked serious challenges. The 1973–1974 oil embargo and subsequent recession, coupled with double-digit inflation, had a negative impact on corporate earnings, and raised doubts about the wisdom of building remote branches accessible only by long drives. Despite these challenges, by the end of the bicentennial year, Strawbridge & Clothier had launched plans for a 10th branch store in the Christiana Mall in Delaware and for four more Clover stores.

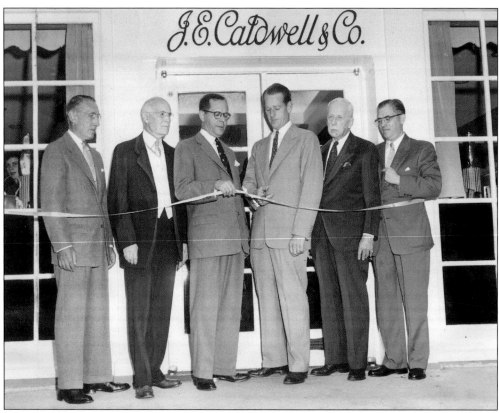

Along with department stores, Chestnut Street specialty stores also followed their upscale customers to the suburbs. In September 1954, J.E. Caldwell & Co. opened its first suburban branch in Haverford (it already had a store in Wilmington's Hotel DuPont). At the opening ceremonies above, from left to right, assistant treasurer John Spencer, treasurer and vice president Eugene T. Jump, president Austin Homer, director J. Morton Caldwell, chairman Charles W. Oakford, and secretary Joseph W. Harbage prepare to cut the ribbon. By the 1980s, the jewelers would have nearly a dozen branch and mall locations in Pennsylvania, New Jersey, and Maryland. In 1957, the Blum Store announced plans to open a suburban branch designed by Thalheimer & Weitz on City Avenue between Belmont Avenue and Conshohocken State Road in Bala Cynwyd (below), then an upscale shopping and business district. (Both, TUL/UA.)

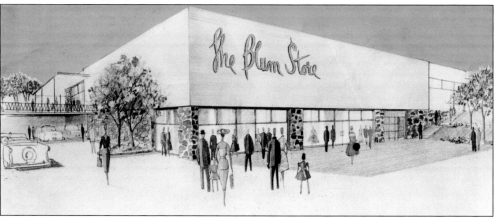

Wanamaker's did not venture outside Philadelphia until 1950, when it opened a $6 million store in Wilmington, Delaware. Preoccupied with winding down its New York operations, Wanamaker's waited until December 1954 before opening its first suburban Philadelphia branch at Wynnewood on the Main Line. Four years later, it opened its second local branch in Jenkintown, on the grounds of the former Baederwood Golf Club (above). The 165,000-square-foot building on the Old York Road was one mile north of the Strawbridge & Clothier branch. Trying to counter Strawbridge & Clothier's successful Cherry Hill store, Wanamaker's teamed with Gimbels to develop an indoor shopping mall at Moorestown, New Jersey, which opened in 1963 (below). The 190,000-square-foot store was fronted by a variation of the iconic Center City eagle, set in a two-tier fountain. (Above, OYRHS; below, Bruce Conner.)

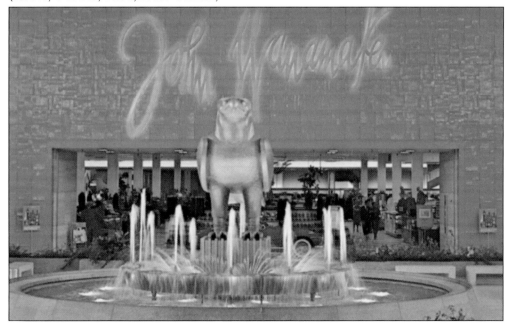

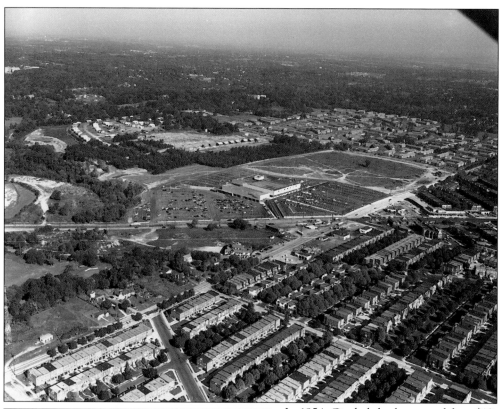

In 1954, Gimbels broke ground for a $10 million store at Ogontz and Cheltenham Avenues in Cheltenham Township (left, looking northeast). The largest Gimbels store in the Delaware Valley offered 250,000 square feet of selling space and 150 departments on three levels, with parking space for 8,000 cars on two levels. Over 5,000 people attended the opening day ceremonies on August 29, 1955. (OYRHS.)

With its access to the Sixty-ninth Street Terminal and the suburbs of Delaware County, Upper Darby continued to be a popular location for branch stores. In 1957, Gimbels opened another $10 million store at Sixty-ninth Street and Walnut Avenue in Upper Darby. Since this was Gimbels' third store, many triplets were invited to the opening ceremonies on August 26, 1957. Here, three of them watch television personality Steve Allen hoist the American flag. (TUL/UA.)

In 1951, Snellenburg's was acquired by Bankers Securities Corporation, which also owned interests in Lit Brothers and Gimbels. Despite the acquisition, Snellenburg's operated as an independent company during the 1950s, using the infusion of capital to build suburban branches. In October 1953, Snellenburg's opened a store at Easton and York Roads in Willow Grove, several miles north of Strawbridge & Clothier's Jenkintown store (above). Nearly 5,000 shoppers mobbed the 80,000-square-foot, two-level store after its dedication (below). During the 1950s, Snellenburg's opened two other branches (in South Philadelphia and Lawrence Park, Delaware County) and acquired the M.E. Blatt department store in Atlantic City. In 1962, Lit Brothers acquired all four of Snellenburg's satellite locations, leaving Snellenburg's flagship store at Twelfth and Market Streets as its sole outlet. (Above, Upper Moreland Historical Association; below, TUL/UA.)

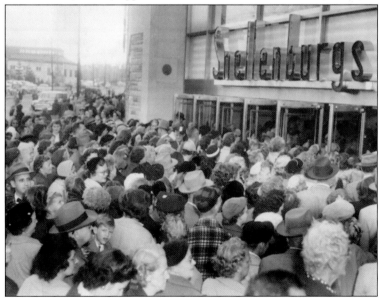

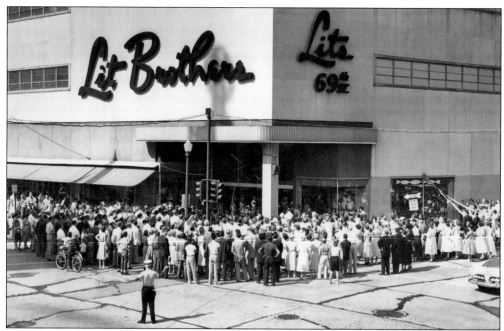

Like its competitors, Lit Brothers expanded during the postwar period, although its branch locations tended to be in more urban, blue-collar settings. In 1949, its first branch, Lits 69th Street, opened at the southwest corner of Ludlow and Sixty-ninth Streets in Upper Darby. The store was so successful that Lits added two new stories, which debuted with great fanfare in July 1957 (above). In 1951, Lits acquired the former Camden County Courthouse at Broadway and Federal Street, the major intersection in what was still a bustling industrial city. The 45-year-old domed courthouse was replaced by a modern, four-floor department store. On October 12, 1955, Lits Camden held its opening ceremonies, with store president Max Robb addressing the crowds (below). Eventually, Lits would grow to over a dozen stores, including its 1962 Snellenburg's acquisitions. (Above, PPC/FLOP; below, TUL/UA.)

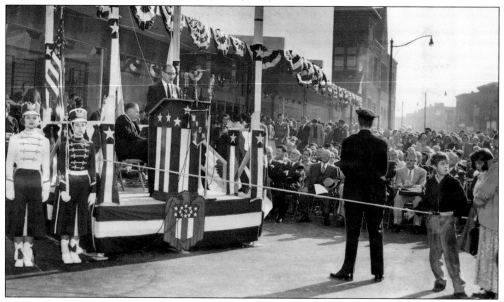

The rapid development of northeast Philadelphia after World War II offered department stores more opportunities for expansion within city limits. Between 1950 and 1960, the population of northeast Philadelphia tripled to 300,000, the only region of the city to grow during this decade. Acres of farmland were quickly replaced by thousands of row houses, while Roosevelt Boulevard, the major artery, became a thriving commercial district. In 1952, the presidents of Lit Brothers and Food Fair Stores, a local supermarket chain, announced plans to develop an urban shopping center at the northeast corner of Cottman Street and Castor Avenue, near Roosevelt Boulevard. The photograph above shows the site during construction in 1953; the view below shows Lits Northeast shortly after its opening in February 1954.

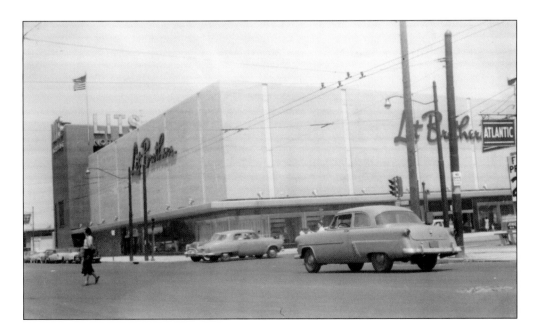

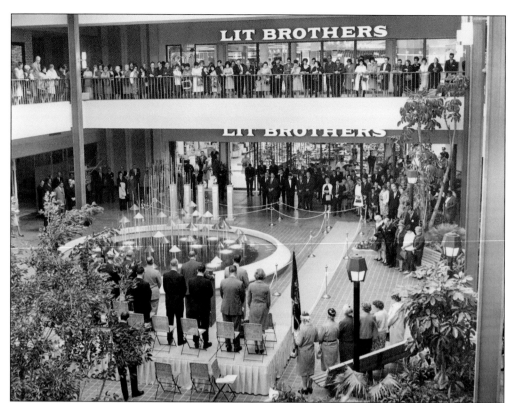

Eventually, Lit Brothers followed its competitors to suburban malls, often partnering with the more upscale Strawbridge & Clothier to ensure a good retail mix. In 1966, Lit Brothers opened its 11th store at the new Plymouth Meeting Mall, on Germantown Pike near the intersection of the Pennsylvania Turnpike and the planned Blue Route. The 185,000-square-foot store anchored the eastern end, while Strawbridge & Clothier occupied the west end. The photograph above shows the dedication ceremony on October 10, 1966. Today, the Lits store is occupied by Boscov's, while Macy's has replaced Strawbridge & Clothier. In 1970, Lits joined Strawbridge & Clothier at the Echelon Mall in Voorhees, New Jersey (below). As with Plymouth Meeting, the two stores have been replaced by Boscov's and Macy's at what is now the Voorhees Town Center. (Above, TUL/UA; below, Paul M. Puccio.)

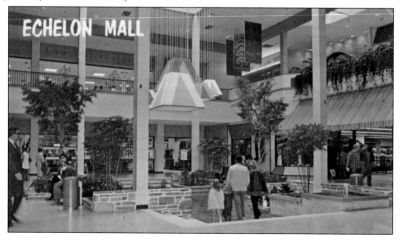

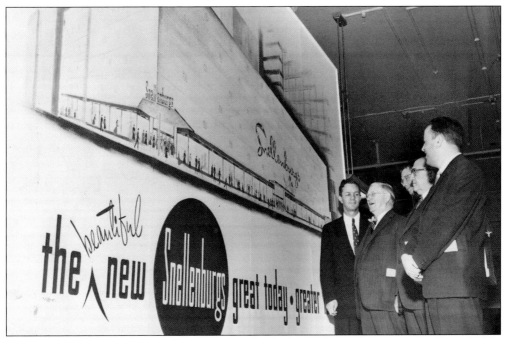

While suburban branches blossomed, Philadelphia stores worried over declining sales at their shabby Market Street flagships. In April 1954, Snellenburg's unveiled plans for a $4.5 million transformation of its Center City store. Here, the plans are inspected by Mayor Joseph S. Clark; John A. Diemand, Board of City Trusts chairman; Walter P. Miller, chamber of commerce president; Albert M. Greenfield, Bankers Securities Corporation president; and Alfred Blasband, Snellenburg's president. (TUL/UA.)

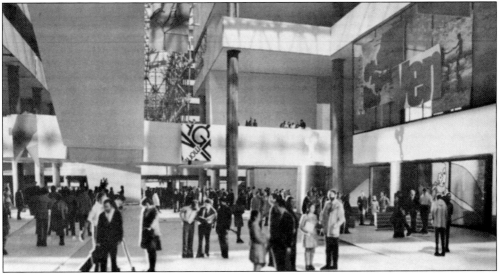

By the mid-1960s, sales at Market Street department stores had contracted to the extent that Snellenburg's was gone and both Lits and Gimbels were considering closing their Center City flagships. In response, the Philadelphia Redevelopment Authority drew up plans for a $750 million renewal of Market Street East between Broad and Fifth Streets. Its centerpiece was the Gallery, a multilevel inner-city mall, shown above in a 1969 architect's sketch.

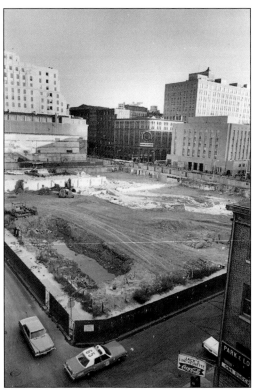

The Gallery was to be anchored at its eastern end by Strawbridge & Clothier's existing store. Gimbels announced plans to abandon its dilapidated flagship across Market Street and move into a new five-level store at the western end of the Gallery. Some competitors grumbled that Gimbels was using public funds to finance its new quarters, but Gimbels had predicated its continued presence in Center City on its move to the Gallery. (TUL/UA.)

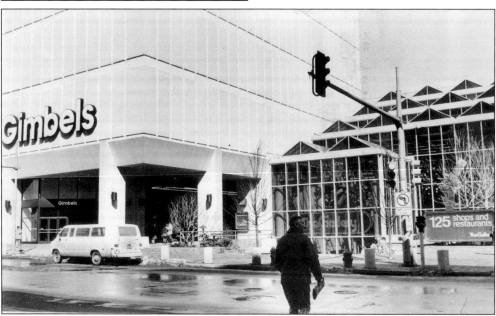

With Gimbels installed in its new home, the Gallery opened in August 1977, followed by a second stage in 1983. The three-block long complex between Eleventh and Eighth Streets added over one million square feet of retail space to Market Street, along with 230 stores and restaurants. While the Gallery revitalized the commercial scene on Market Street East, it did not prevent the further decline of department stores along the street.

Nine

THE END OF AN ERA

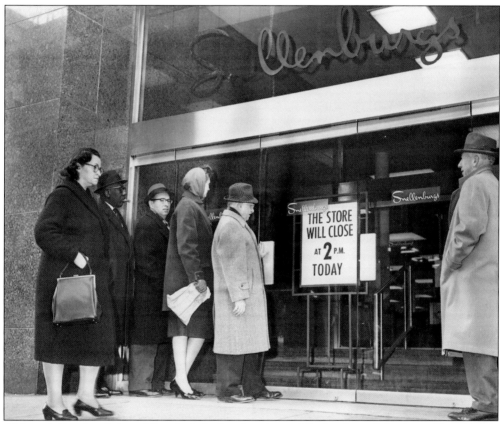

Although Pittsburgh-based Frank & Seder closed in 1953, the first of the large Philadelphia department stores to fold was N. Snellenburg & Co. in 1963. Despite a $5.5 million face-lift in 1956, sales at Snellenburg's Center City flagship declined in the early 1960s. Its corporate parent, Bankers Securities Corporation, also had a controlling interest in Lit Brothers. Since Lits and Snellenburg's competed for the same working-class market, it made financial sense to shutter the weaker store. On February 15, 1963, customers were asked to leave Snellenburg's at 2:00 p.m. and its 500 workers were informed that they were unemployed. (TUL/UA.)

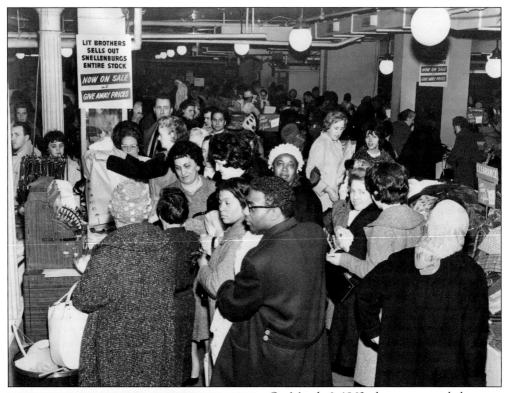

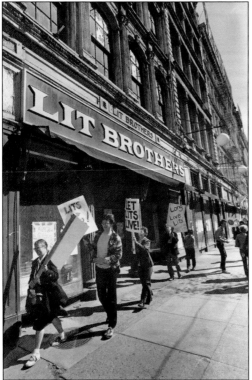

On March 6, 1963, shoppers crowded into Lits Bargain Basement for a sale of all items liquidated by Snellenburg's. Two years later, the Girard Trust had Snellenburg's massive flagship store completely remodeled by Thalheimer & Weltz into a complex called Girard Square. The top four stories were demolished, and the remaining floors hidden underneath a modern facade and converted to office and retail space. (TUL/UA.)

In April 1977, Lit Brothers announced that it would close at the end of the month. Despite being listed in the National Register of Historic Places, its Market Street store was at risk of being demolished when its bankrupt owner was unable to find a new buyer. The "Let Lits Live Coalition," organized by Ellen Gesensway, lobbied authorities and organized demonstrations to draw public attention to the building's plight. (TUL/UA.)

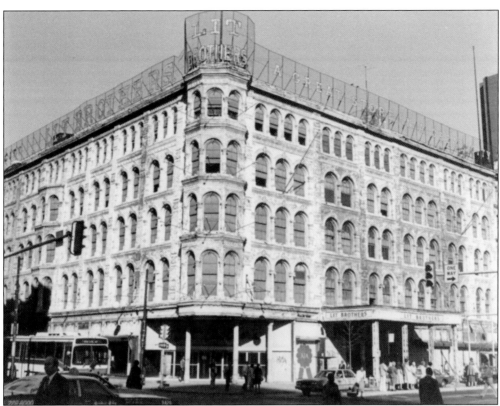

For nearly a decade after Lits closed, its former flagship rotted while its fate hung in the balance (above). On at least two occasions, the Philadelphia Historical Commission approved plans for demolition, only to withdraw them when preservation plans were presented. In November 1985, Mellon Bank came to the building's rescue by signing a 25-year agreement to lease half of the building's space. The largest historic restoration in Philadelphia history—costing nearly $90 million and taking two years—transformed the derelict building. On October 23, 1987, the former Lit Brothers was rechristened as the Mellon Independence Center (right), with over 50 stores and restaurants on its ground floor and concourse. The reopening of the building coincided with the completion of the city's $15 million face-lift of Market Street East. (Both, PPC/FLOP.)

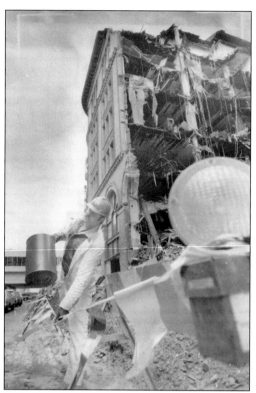

After Gimbels relocated to the Gallery in August 1977, there was no demand for its former store. In late 1979 and early 1980, the vast complex on Market between Eighth and Ninth Streets was demolished (left), except for the 1927 Chestnut Street addition. Gimbels would remain a Gallery anchor until 1986, when its corporate parent divested itself of the 36-store chain. Today, Gimbels' former Gallery store, its four floors reduced to two, houses a K-Mart. (TUL/UA.)

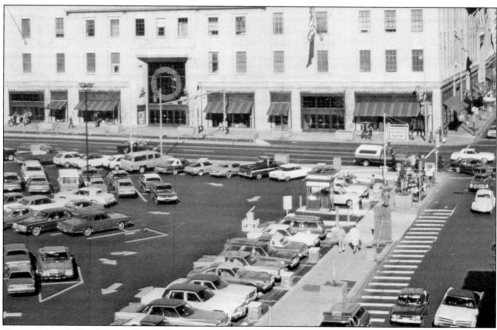

Once cleared, the former Gimbels site was paved over for "temporary" use as a parking lot, as seen here in the early 1980s. Over three decades later, the site is still used for parking, despite failed plans for a variety of projects, including a Sears store and a DisneyQuest indoor theme park. (Mr. and Mrs. Francis R. Strawbridge III.)

As the Center City retail market changed, many of the upscale specialty stores on Chestnut Street found that their customer base had disappeared. In the 1960s, the Blum Store left the hands of the Spector Herr family when it was acquired by Weiss Stores. But by the mid-1970s, the store's chic customer base had deserted Center City for more exclusive suburban venues, such as the Main Line and King of Prussia. In 1975, Weiss liquidated its Blum branches, and finally closed its struggling flagship in 1976. This faded mural showing Blum's trademark black-gloved hand clutching a lacy parasol can still be seen on the upper rear wall of its Chestnut Street site. Ironically, the site of one of Philadelphia's finest fashion stores is occupied today by I. Goldberg, "Philadelphia's original Army & Navy store." (Photograph by Tim McFarlane, 2011.)

Strawbridge & Clothier—the city's last independent, locally owned department store—was acquired in 1996 by the May Department Stores Company, which had taken over Wanamaker's the year before. The 27 Clover stores were sold separately, while the 14-outlet department store chain was renamed Strawbridge's. When May was acquired by Federated Department Stores in 2005, the new corporate parent consolidated its holdings. The main Strawbridge & Clothier store at Eighth and Market Streets was shuttered, and the other stores were either sold or converted to Macy's or Bloomingdale's. Today, the upper floors of the former flagship have been converted to office space: *Il Porcellino* still stands guard over a vacated Food Court (above), while cubicles fill the former Corinthian Room (below). In November 2011, the *Philadelphia Inquirer* and *Daily News* newspapers announced plans to move to the former store. (Both, photographs by Laura Dinkins-White.)

After being acquired by May Department Stores in 1995, Wanamaker's name was changed to Hecht's, then to Strawbridge's, and then to Lord & Taylor. In 2006, after being acquired by Federated Department Stores, Inc., the store was re-branded yet again as Macy's. Since then, Macy's has worked admirably to maintain many of Wanamaker's beloved traditions, including support of the musical arts. In September 2008, members of the Philadelphia Orchestra rehearsed for a concert in the Grand Court, reminiscent of those led by Leopold Stokowski in the 1920s. (Photograph by Laura Dinkins-White.)

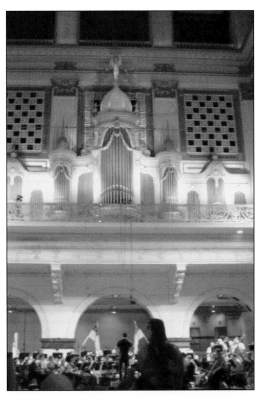

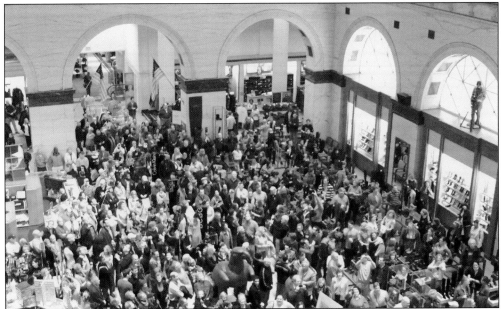

On October 30, 2010, the Grand Court reverberated to the "Hallelujah Chorus" from Handel's *Messiah*, performed by a "flash mob" of over 650 singers organized by the Opera Company of Philadelphia. The "random act of culture," designed to kick off National Opera Week, was cosponsored by Macy's and the John S. and James L. Knight Foundation. (Photograph by Diane Mattis; the Opera Company of Philadelphia.)

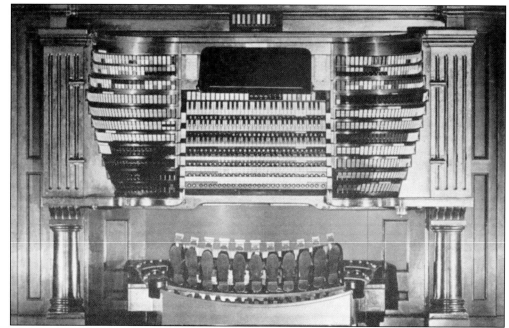

In 2011, both the Wanamaker Building and the Grand Organ (above) celebrated their 100th birthdays. Since 1991, the Friends of the Wanamaker Organ has supported and preserved the historic instrument, now a National Historic Landmark valued at over $57 million. On June 22, 2011, one century from the date that the Grand Organ was first heard, Macy's and the Friends of the Wanamaker Organ celebrated the event in the Grand Court (below). Mayor Michael Nutter (third from left) joined with representatives of the Friends, Macy's, and the Kimmel Center to unveil a bronze plaque commemorating the organ's centennial. Throughout 2011, organist Peter Richard Conte and the Friends of the Wanamaker Organ marked the centenary with concerts, films, broadcasts, and other special events. (Above, Bruce Conner; below, photograph by Jeffrey Holder.)

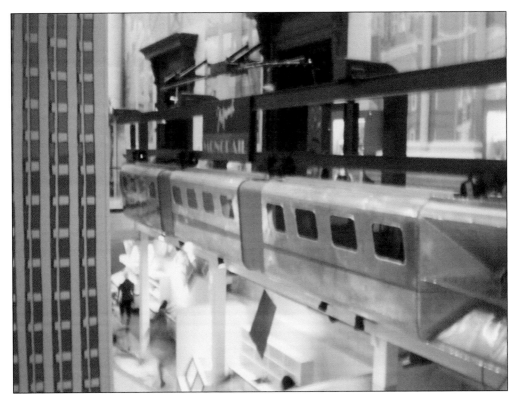

Like flotsam and jetsam salvaged from a shipwreck, bits and pieces of Philadelphia's great department stores have washed ashore at other local institutions. The Please Touch Museum in Fairmount Park has preserved the John Wanamaker monorail, a favorite holiday fixture in the toy department from 1946 until 1984 (above). Although stationary today, the "Rocket Express" still inspires dreams of space-age travel among the museum's young visitors. While the monorail is a permanent exhibit, the Please Touch Museum also displays scenes from Lit Brothers' Enchanted Colonial Village during the Christmas season. Meanwhile, Macy's has adopted the Strawbridge & Clothier Charles Dickens Village as part of its holiday traditions. But most importantly, Philadelphia's golden age of retail still survives in the hearts and minds of thousands of residents of the Delaware Valley, as seen on the license plate holder below.